A PICTORIAL MEMOIR

by SYLVIA ROTHENBERGER MILLER

Sylvia Rothenberger Miller

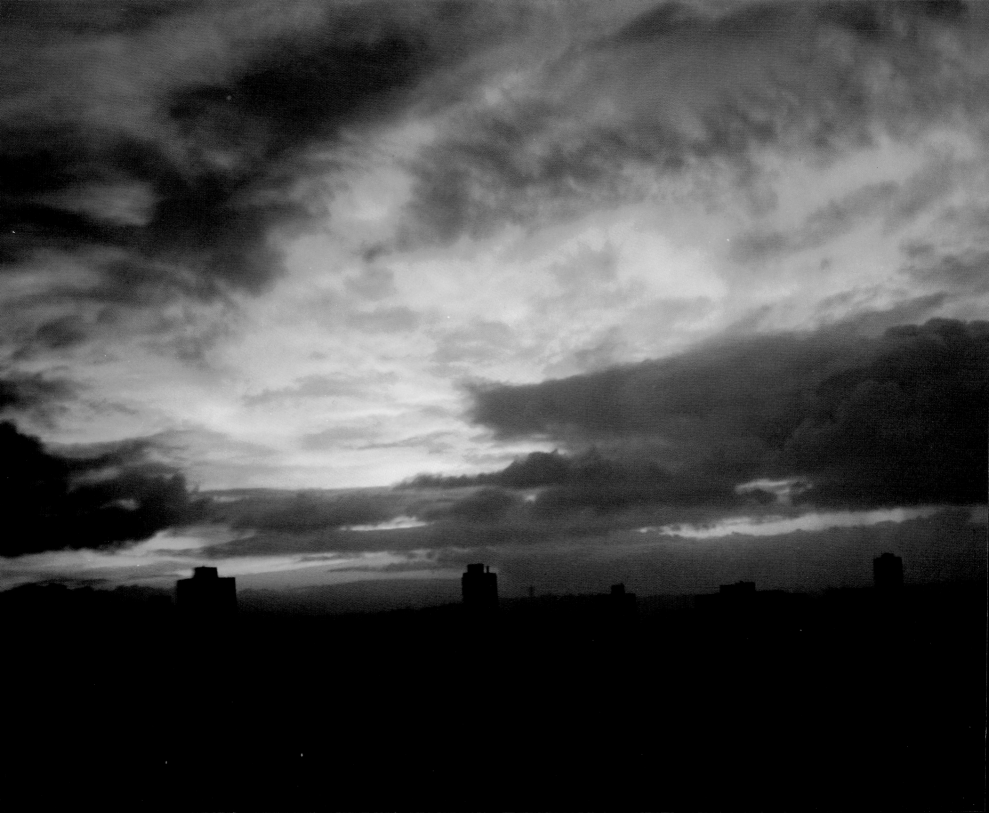

A PICTORIAL MEMOIR

by SYLVIA ROTHENBERGER MILLER

IN THE BEGINNING

NATURE—YES

PEOPLE—YES

ART—YES

THE LOWELL PRESS / KANSAS CITY

FIRST EDITION
Copyright 1980 by Sylvia Rothenberger Miller
L.C. 80-81146 ISBN 0-913504-57-2

This book has been printed in the United States of America on Warren's Flokote Enamel,
an acid-free paper with an expected 300-year library storage life as determined by the
Council of Library Resources of the American Library Association
by
The Lowell Press, Inc. / Kansas City, Missouri

Shown in this 120-page book are 141-full-color photographs
taken in 48 countries around the world.

In memory
of my parents
Kate W. Rothenberger and Harry B. Rothenberger
and to my husband
Arthur J. Miller

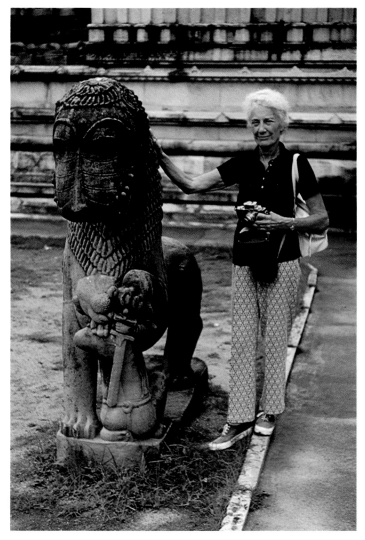

Author and photographer
Khajuraho, India

Photo courtesy of Betty Bricker

Prologue

A joy shared is rendered manifold; thus, I would share my joy with you.

I climbed rugged mountains, traversed limitless desert dunes, sailed oceans wide, descended into the depths of the earth, soared the heavens magnificent. Always I returned to a truism: human nature is everywhere unchanged and fundamentally unchangeable though indeed malleable and myriad in mode of life and living.

In the face of every child I found a gladsome, exultant "Yes!" to life, and because it was so, there is hope for the morrow.

Of little skill with brush or pen, I chose the enlarged vision of the camera's eye to preserve and to reflect that which my mind and my heart encompassed.

I sought truth and beauty, and I found them in nature, art, and the human condition.

Come share joy with me!

SYLVIA ROTHENBERGER MILLER

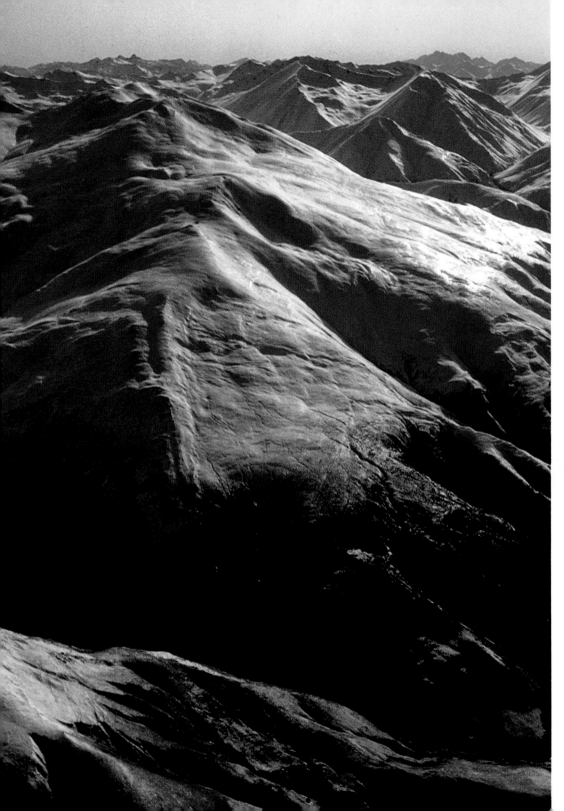

The
Handiwork
of
God

Southern Alps, New Zealand

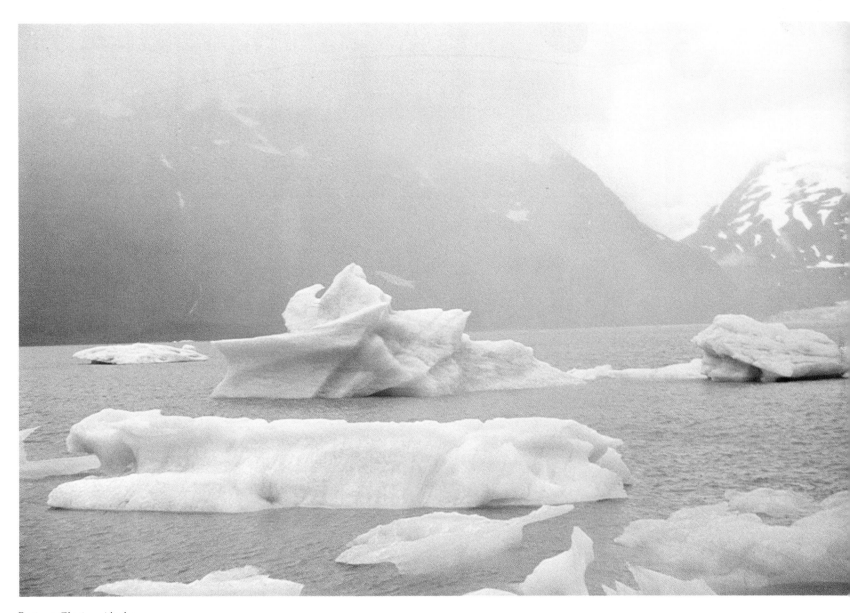

Portage Glacier, Alaska

3

Nature—Yes

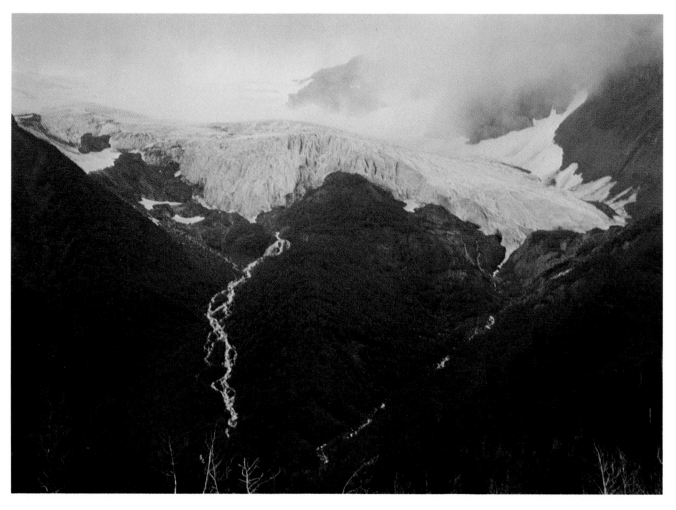

Seward Highway, Alaska

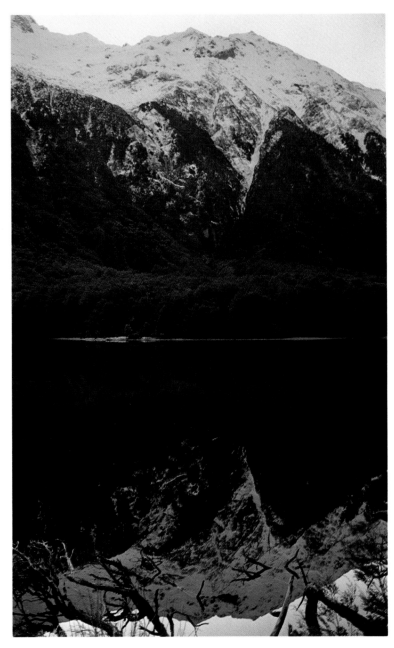

Te Anau Lake, New Zealand

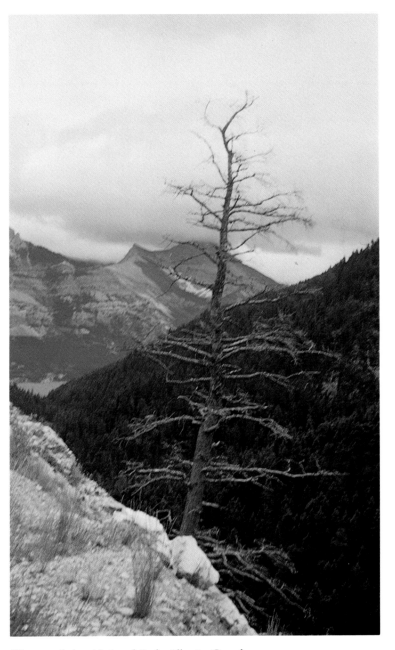

Waterton Lakes National Park, Alberta, Canada

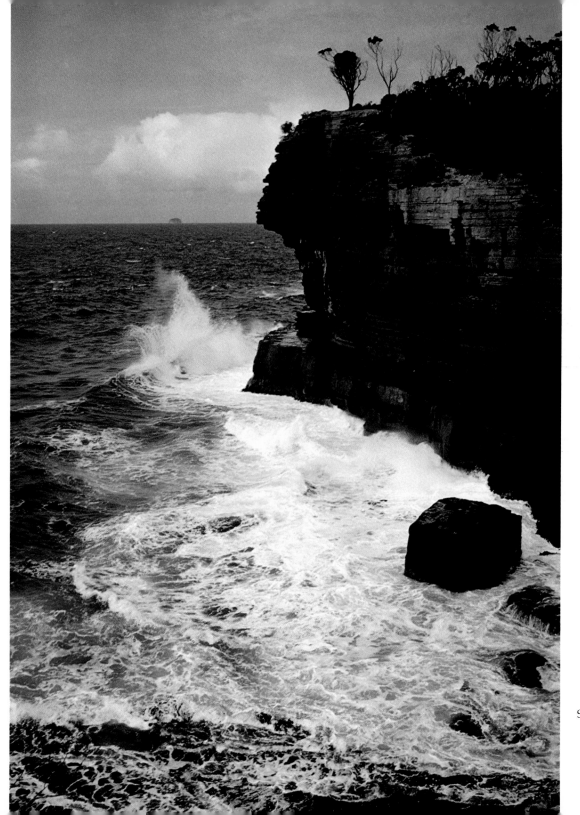

Sea coast, Tasmania, Australia

The Forest Primeval

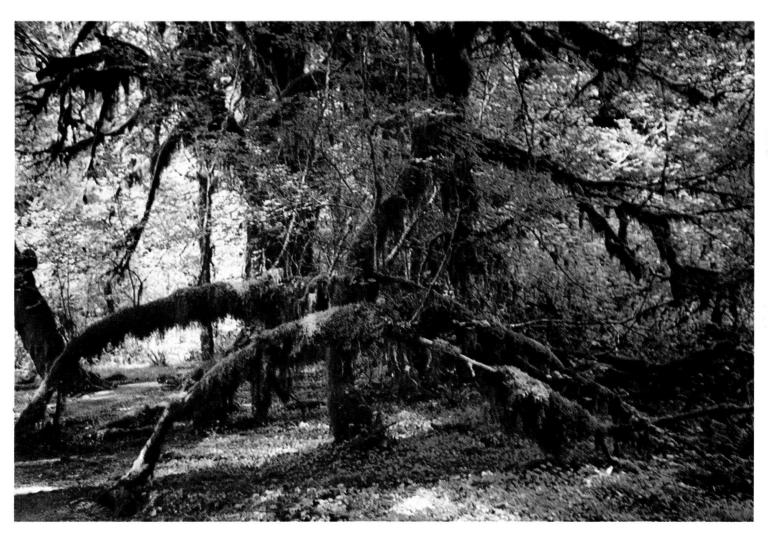

Olympic National Park, Washington

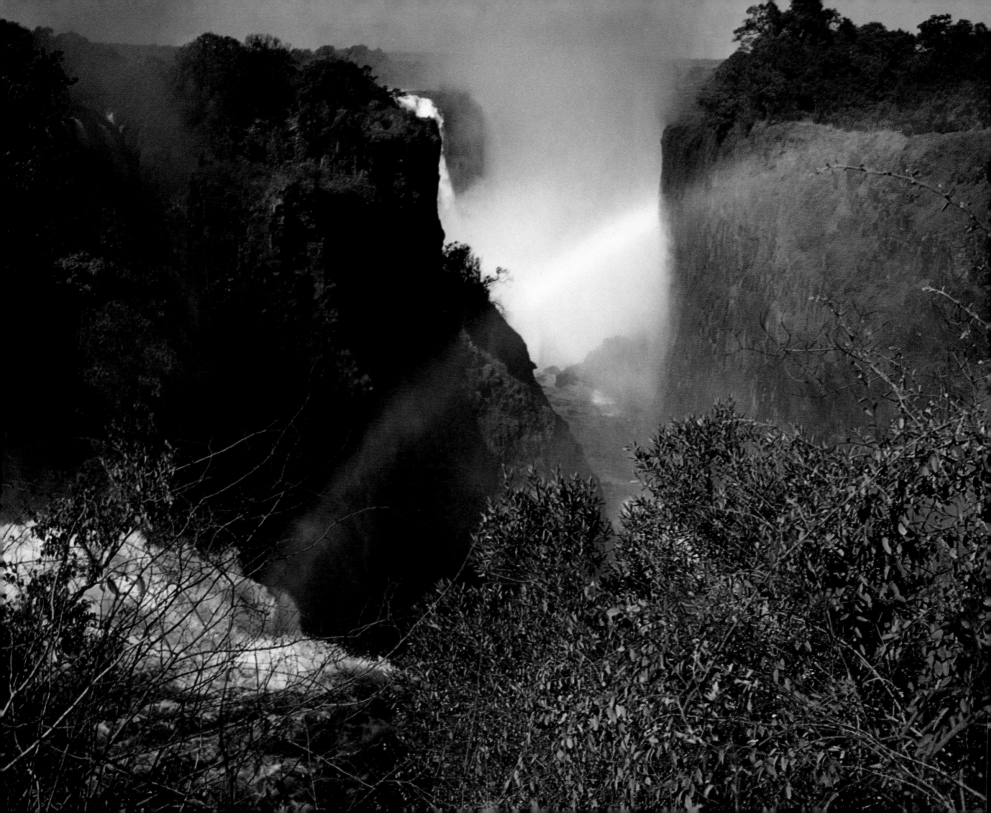

God's

Promise

to

Man

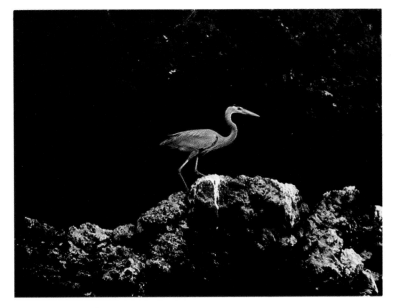

Galapagos Islands

Victoria Falls, Rhodesia

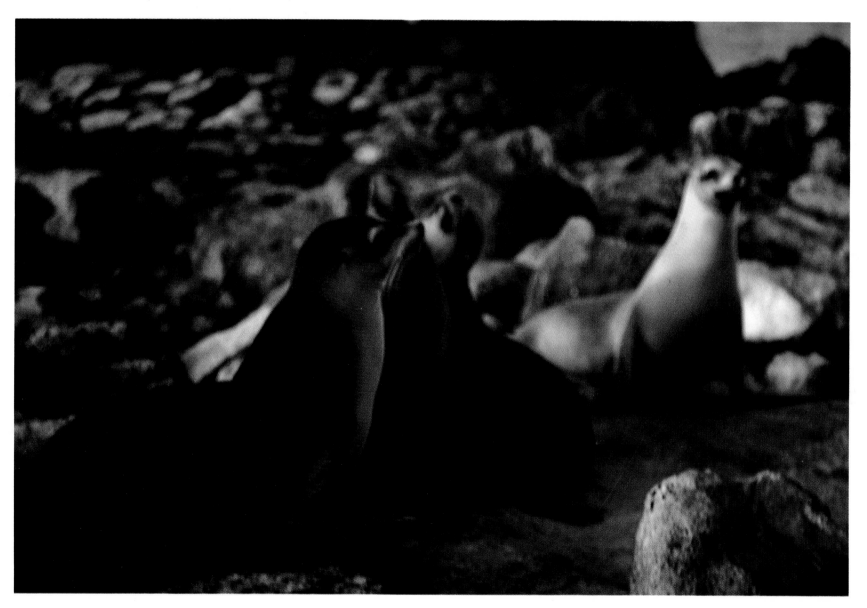

Galapagos Islands

Glory
of the
Sea

Bora Bora, Society Islands

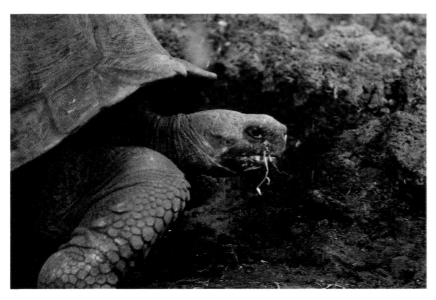

Galapagos Islands

11

Kith and Kinder

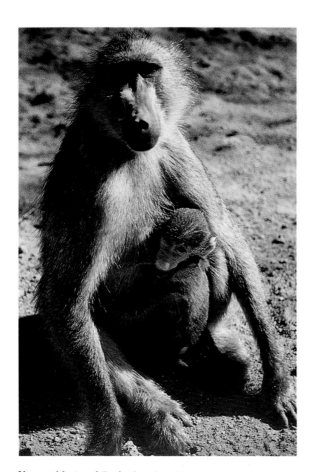

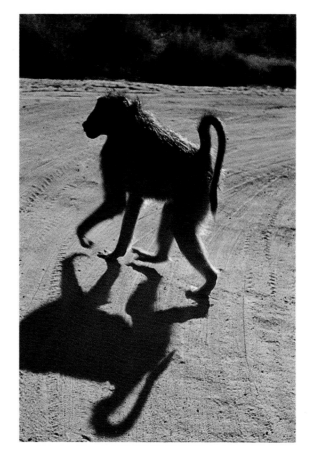

Kruger National Park, South Africa

Kruger National Park, South Africa

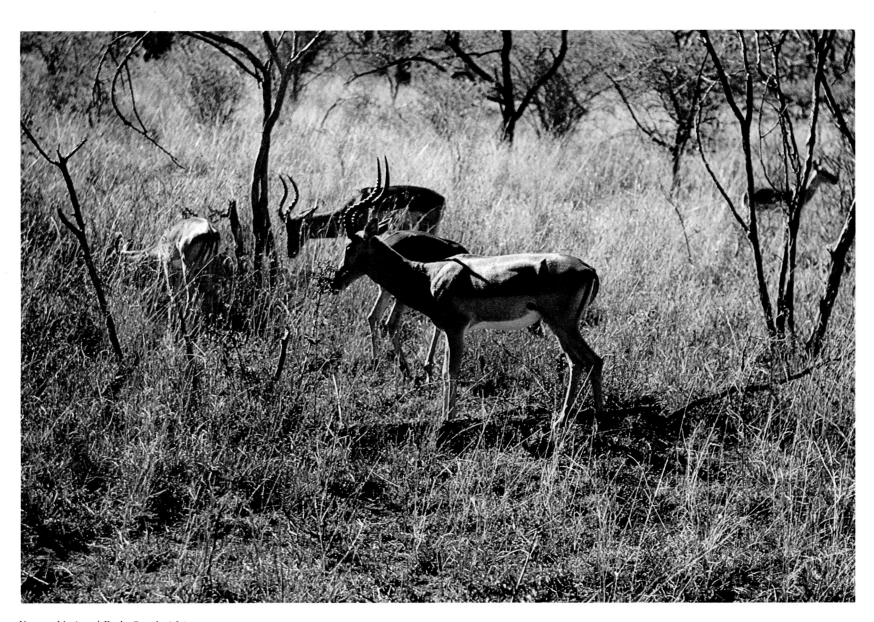

Kruger National Park, South Africa

The Beginning of the Divine Creation

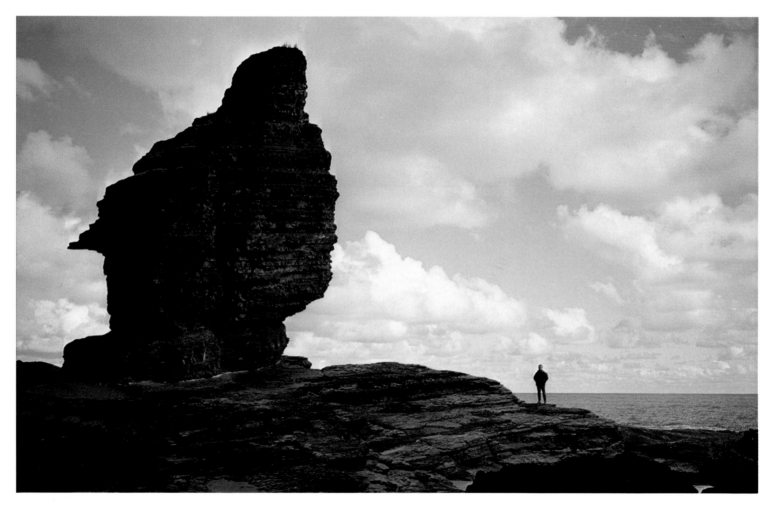

New Caledonia

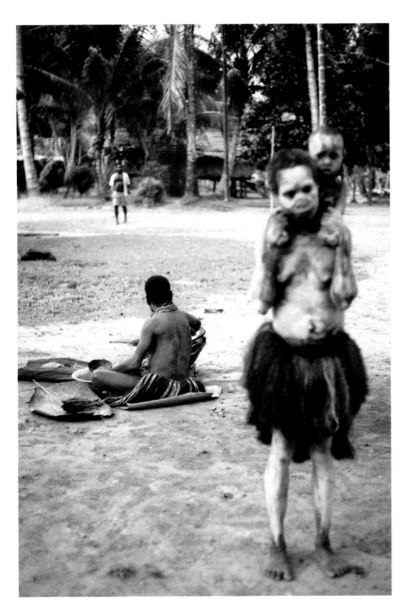

Sepik River, New Guinea

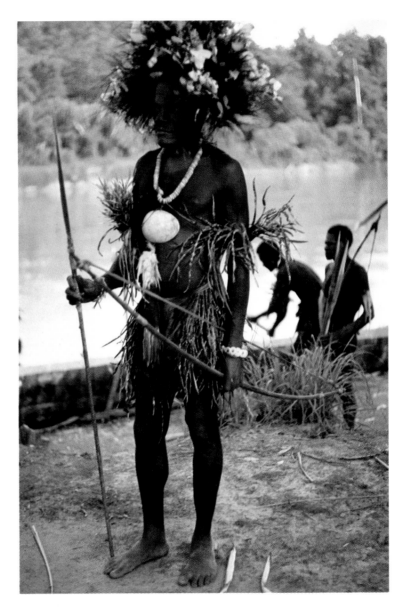

Sepik River, New Guinea

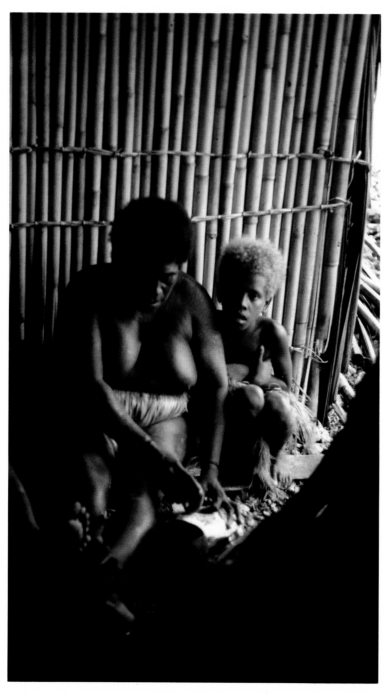

Malaita, Solomon Islands

Time
Stands
Still

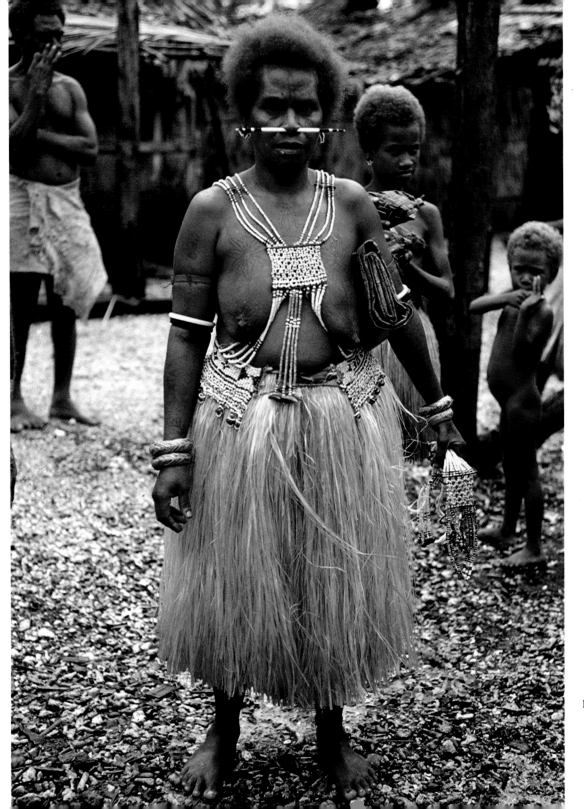

Malaita, Solomon Islands

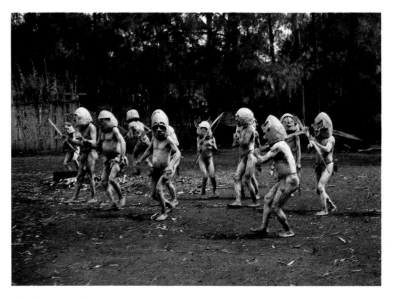

Goroka, New Guinea

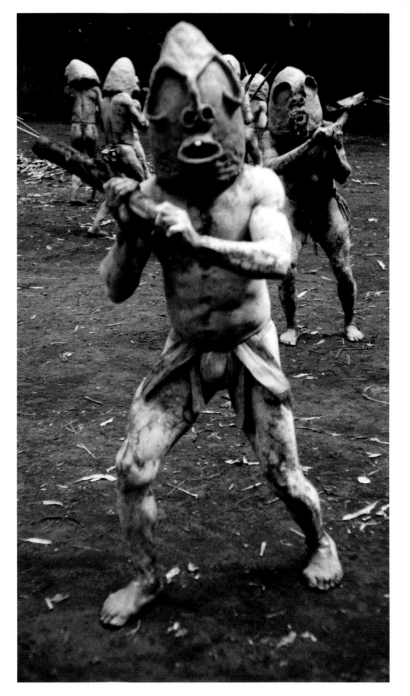

Goroka, New Guinea

The Mudmen

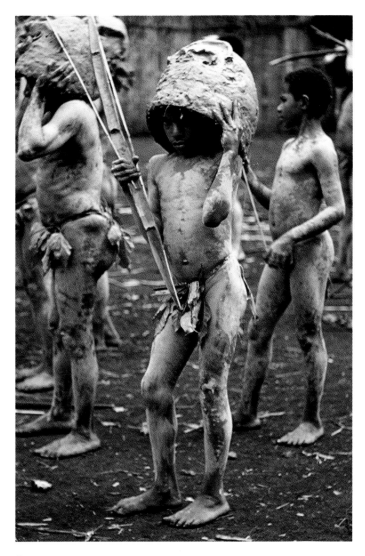

Goroka, New Guinea

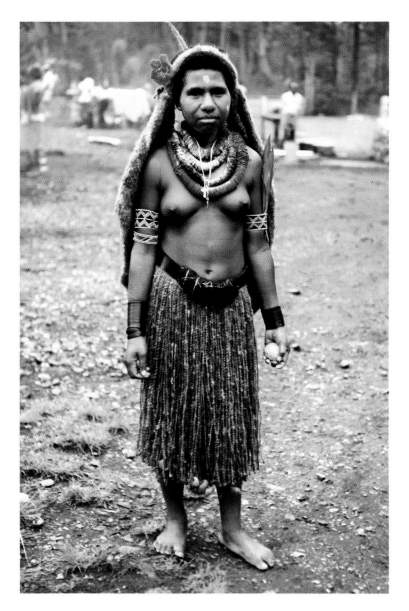

Goroka, New Guinea

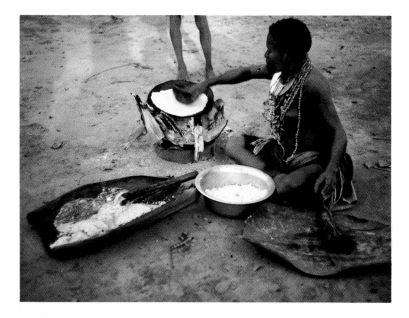

Sepik River, New Guinea

Art—Yes

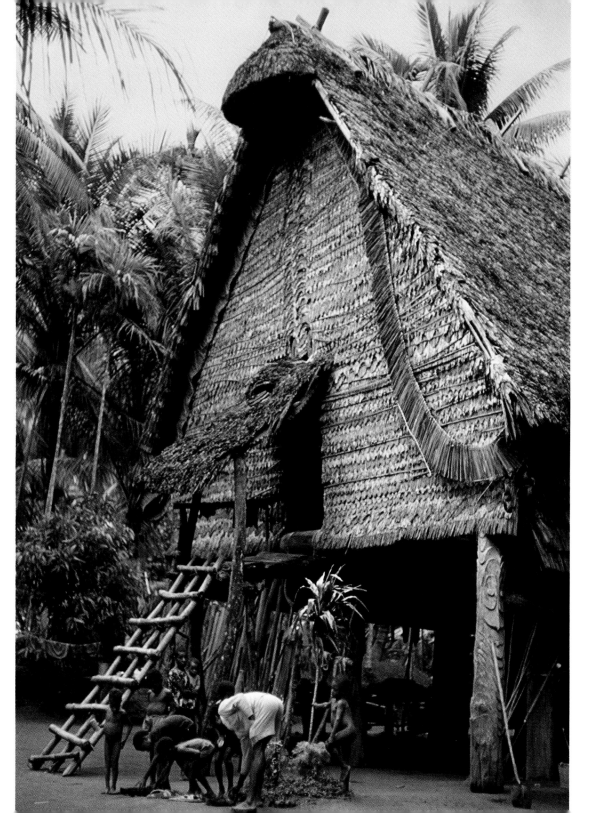

Sepik River, New Guinea

The Innocent and the Childlike

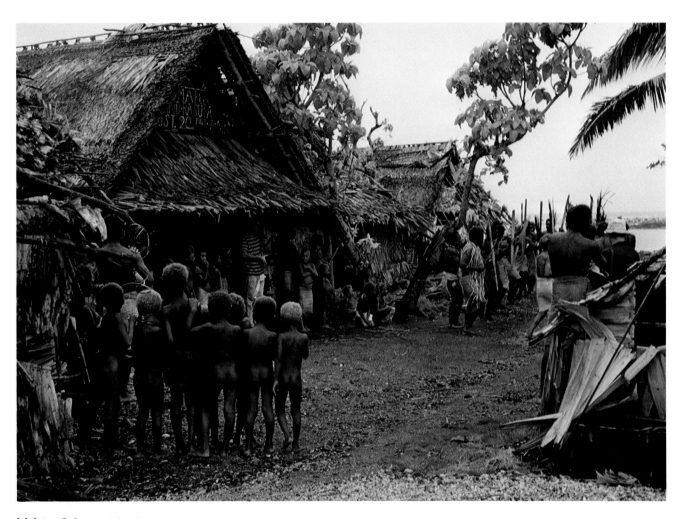

Malaita, Solomon Islands

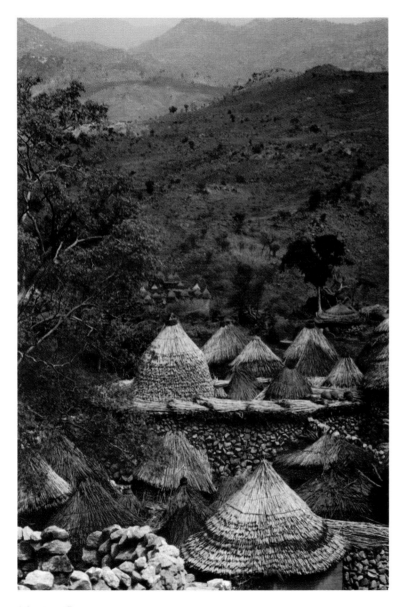

Maroua, Cameroon

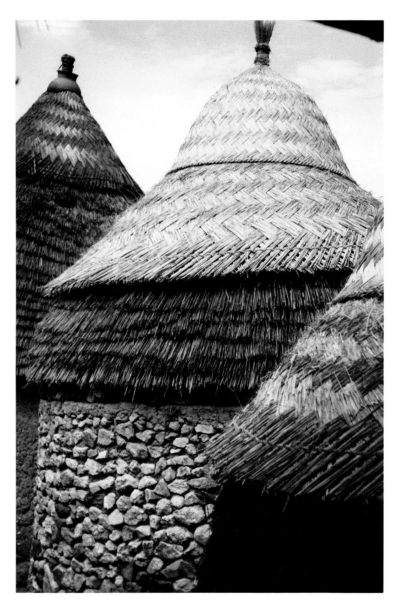

Maroua, Cameroon

People—Yes

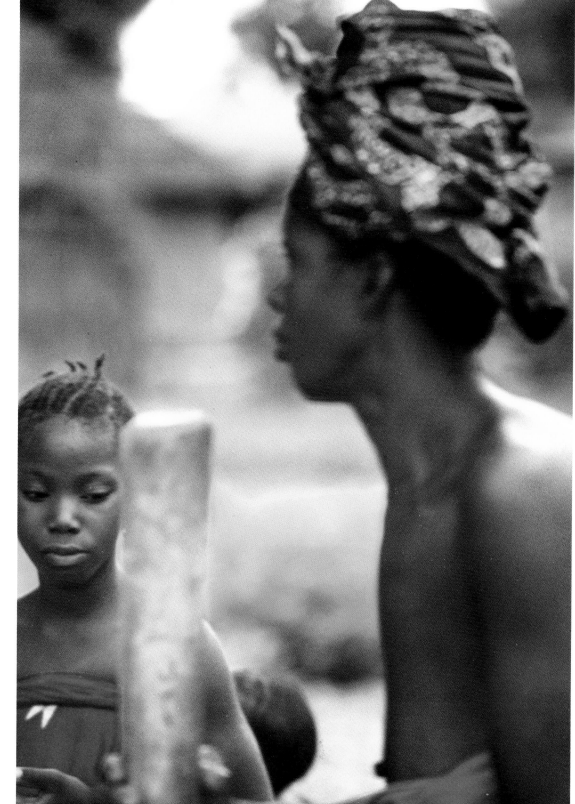

Bamako, Mali

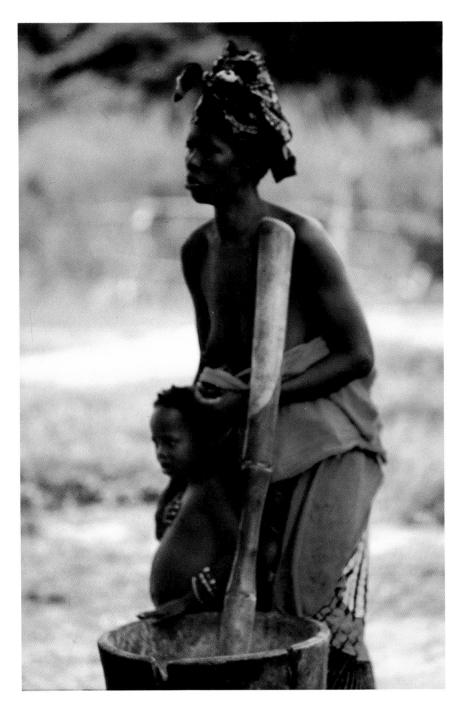

Bamako, Mali

The
Bottom Line

Bamako, Mali

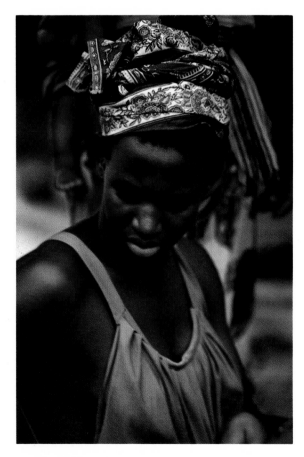

Bamako, Mali

The
Human
Condition

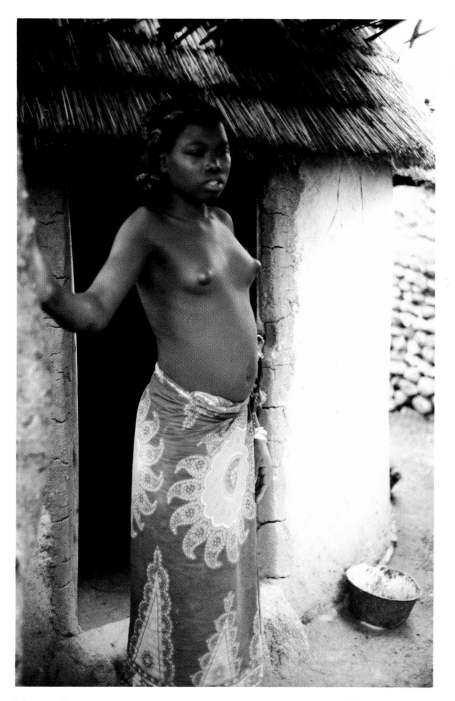

Maroua, Cameroon

The Dignity
of
Labor

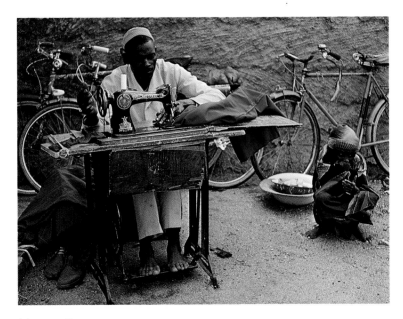

Maroua, Cameroon

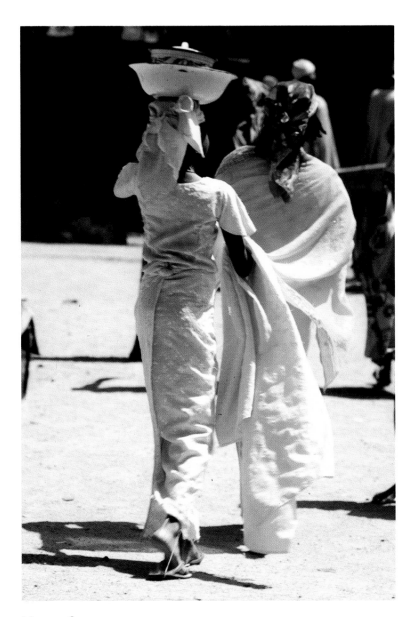

Maroua, Cameroon

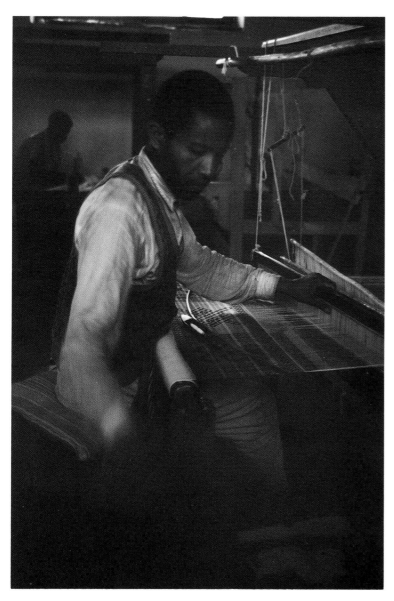

Addis Ababa, Ethiopia

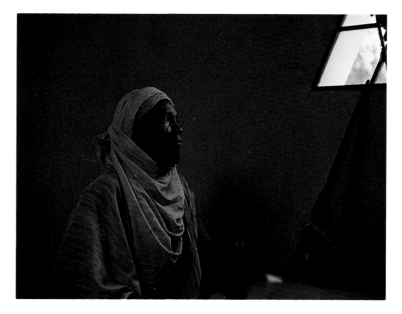

Timbuktu, Mali

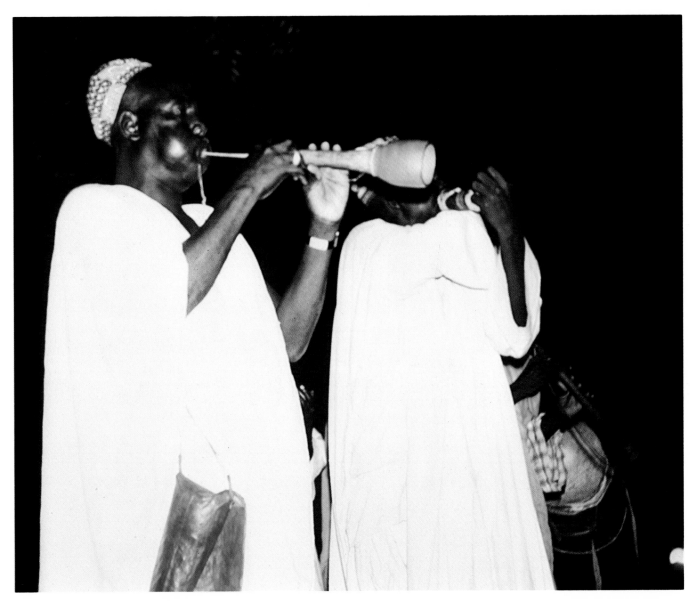

Maroua, Cameroon

L'élan vital!

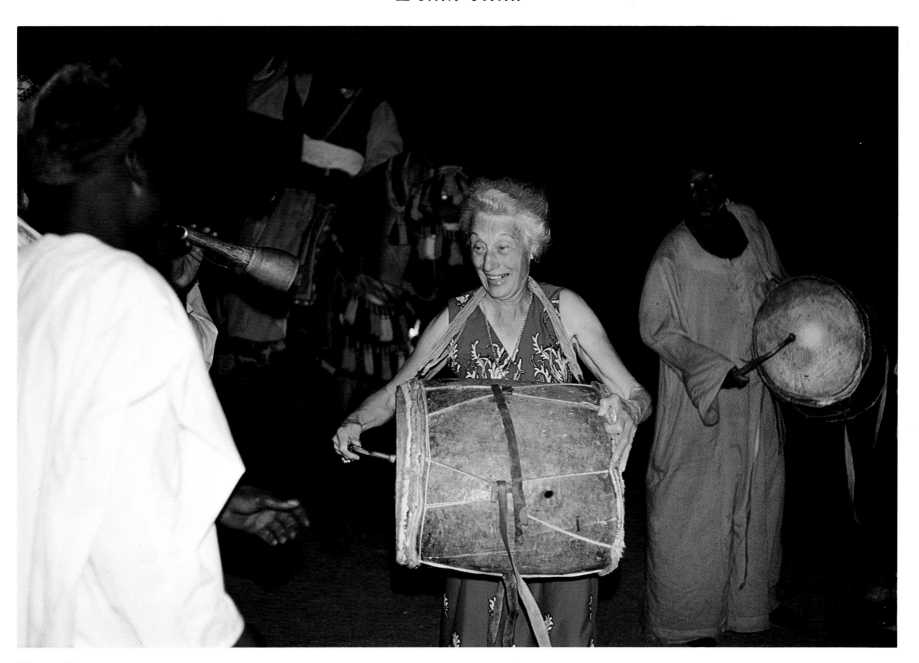

Maroua, Cameroon

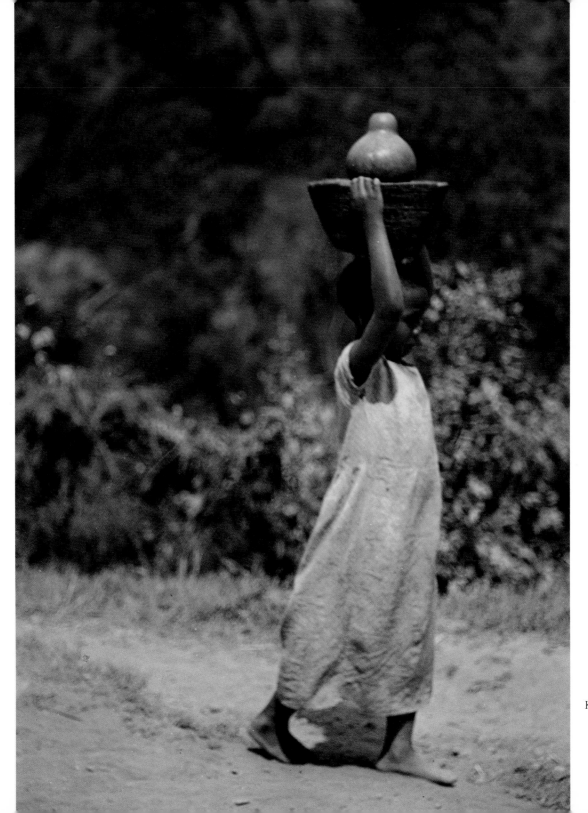

Kampala, Uganda

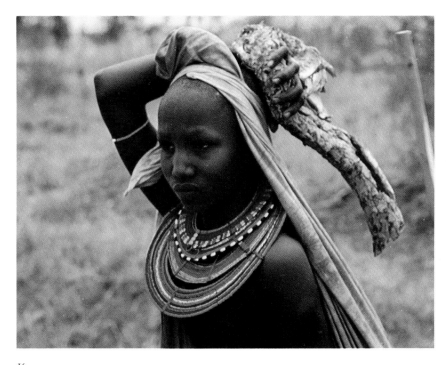

Kenya

Initiation Rites

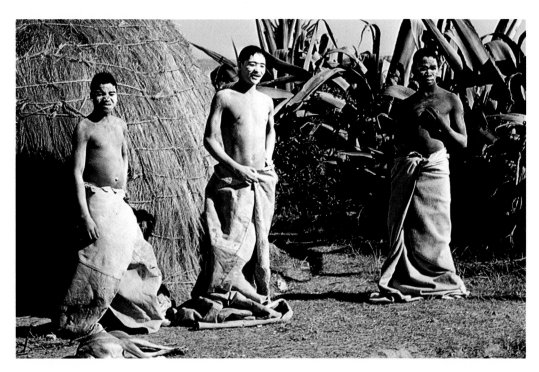

South Africa

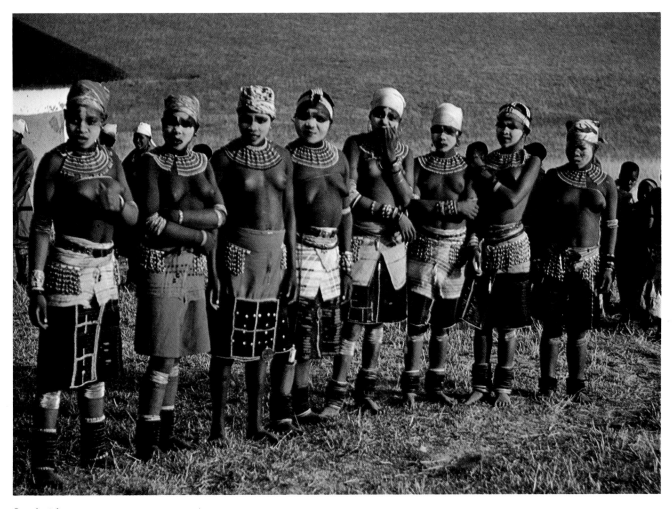

South Africa

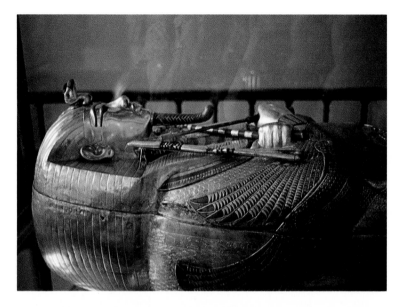

Cairo, Egypt

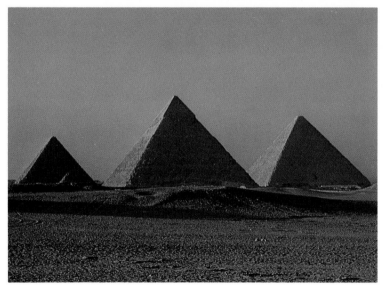

Pyramids of Giza, Egypt

The Mind
and
the Hand
of Man

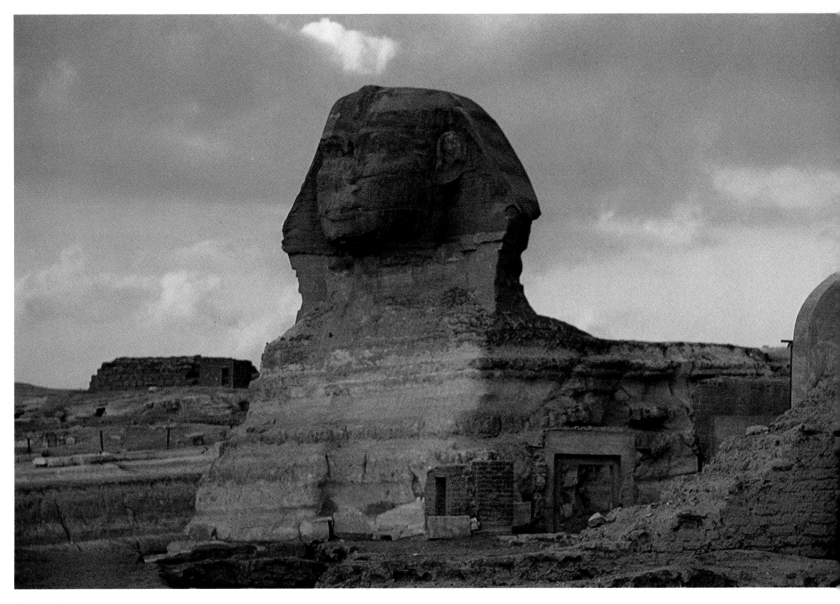

Sphinx, Egypt

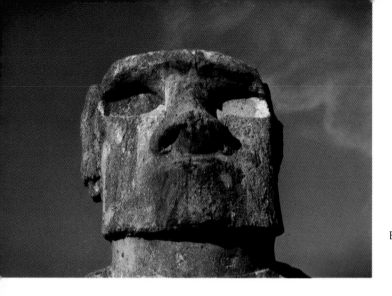

Easter Island

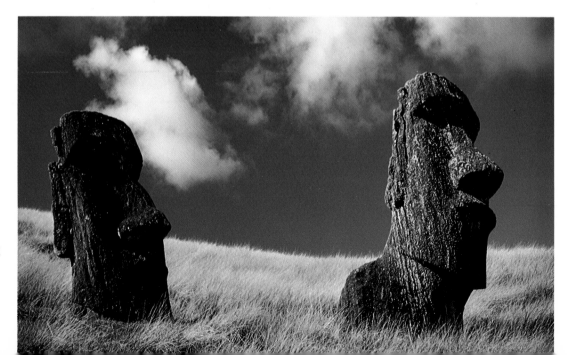

Easter Island

The Silent Grandeur

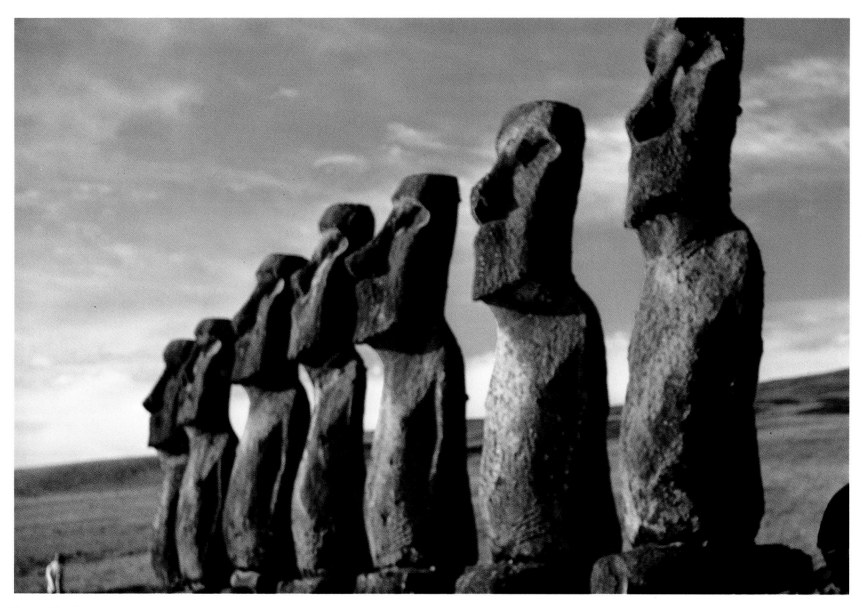

Easter Island

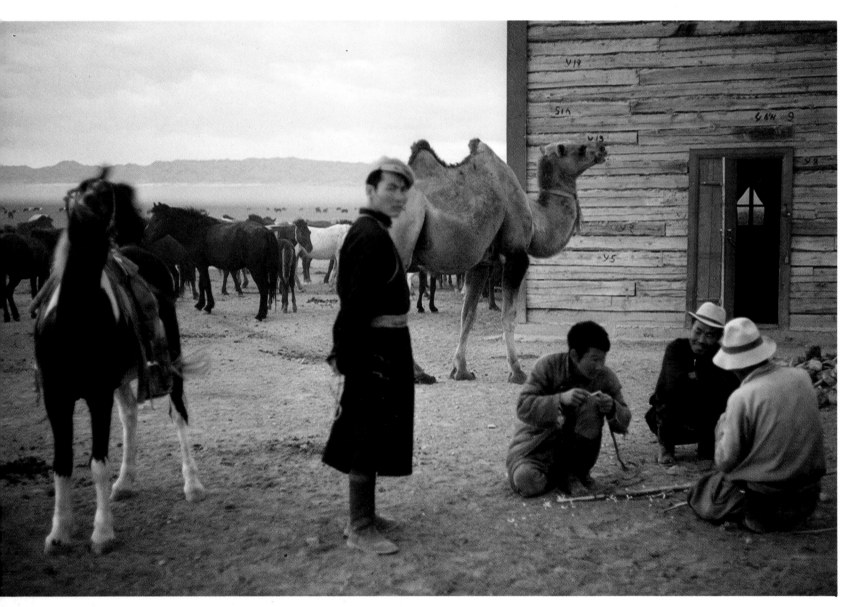

Gobi Desert, Outer Mongolia

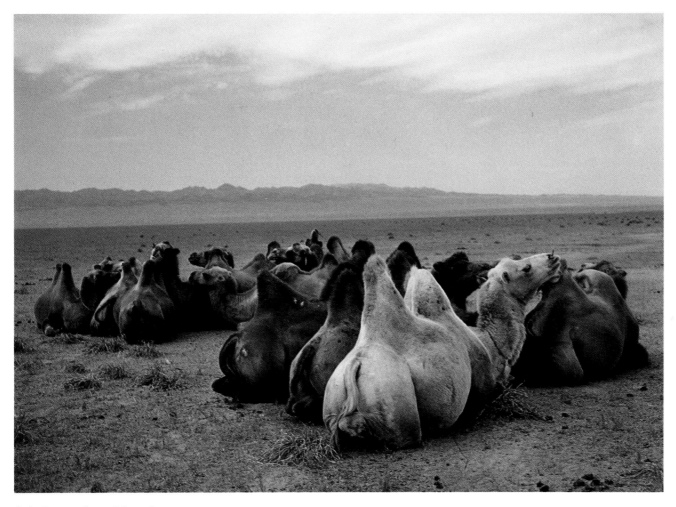

Gobi Desert, Outer Mongolia

Tears Love Laughter

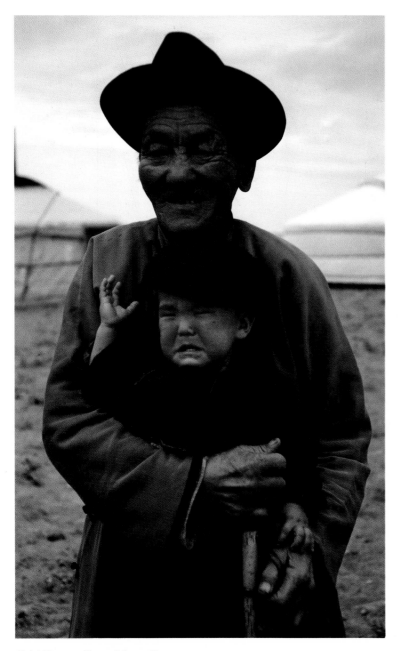

Gobi Desert, Outer Mongolia

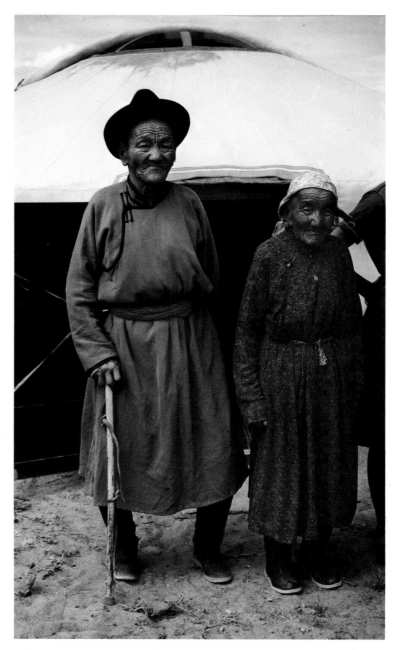

Gobi Desert, Outer Mongolia

Gobi Desert, Outer Mongolia

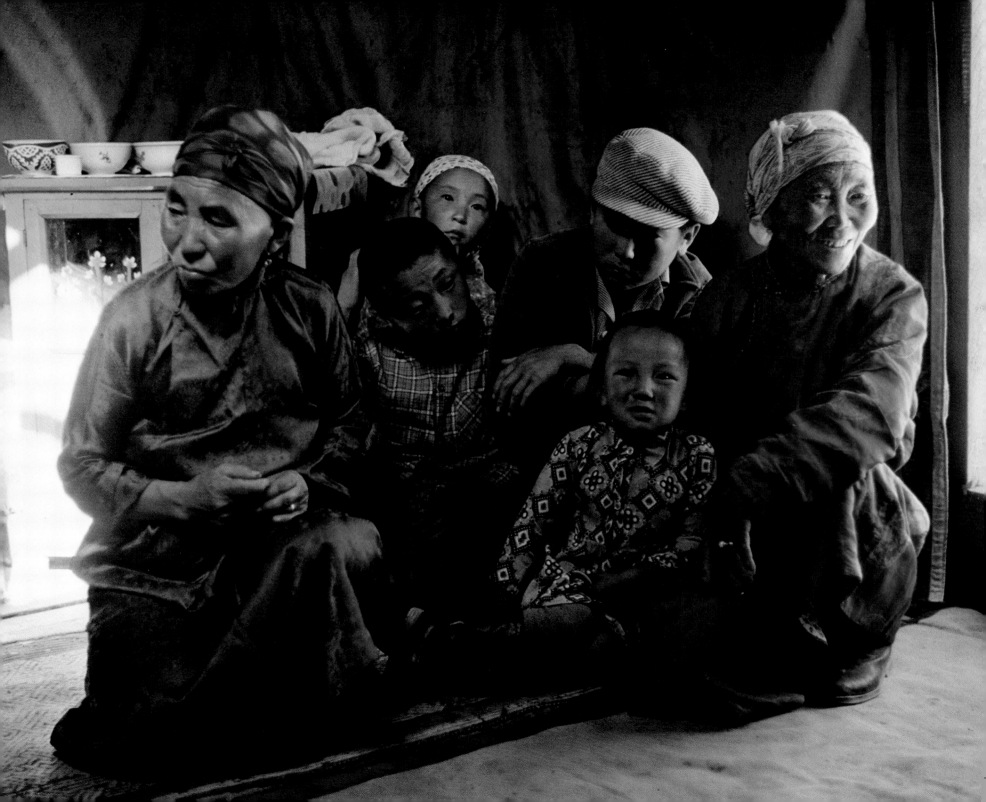

There is no God but God.

MUHAMMAD

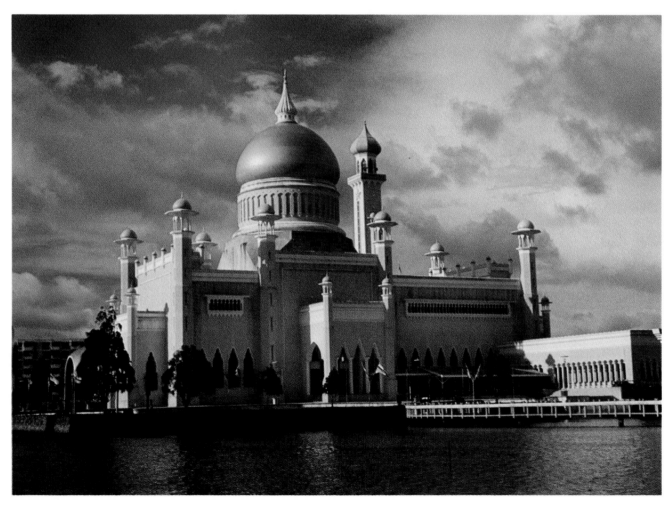

Brunei, Borneo

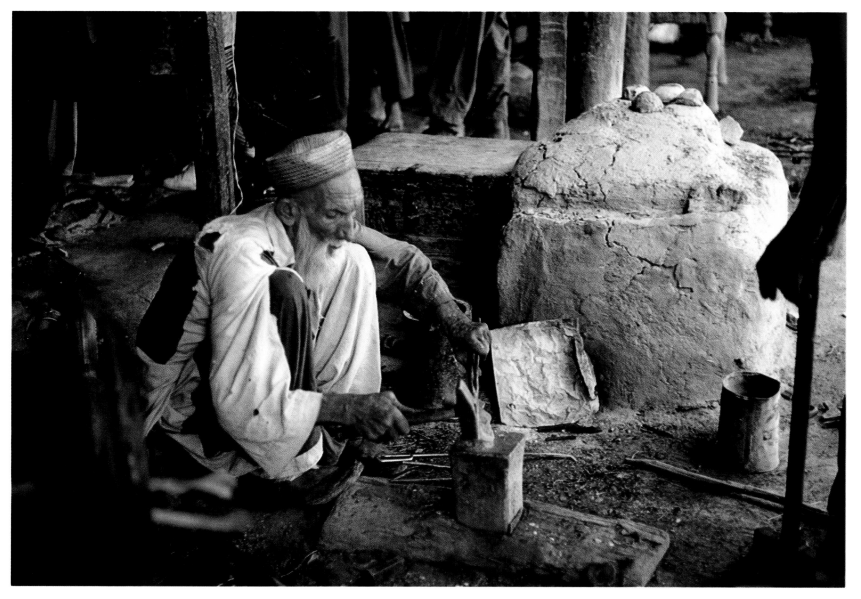

Peshawar, Pakistan

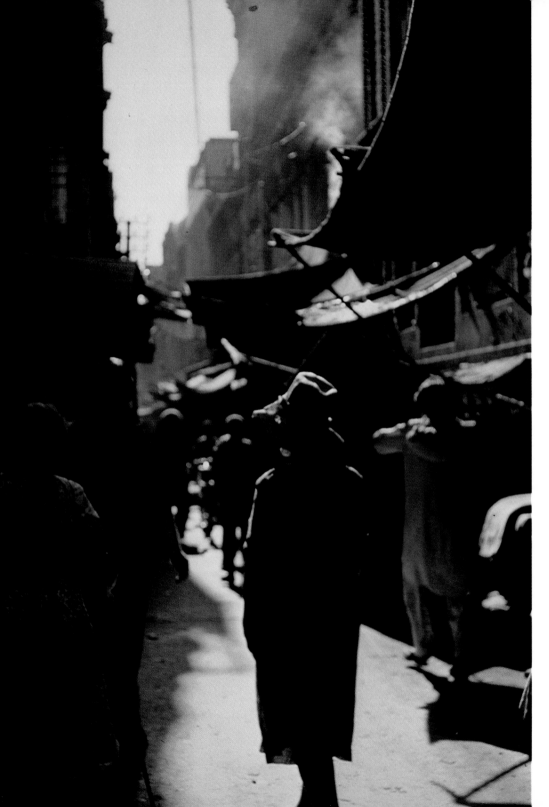

Peshawar, Pakistan

Haute Cuisine

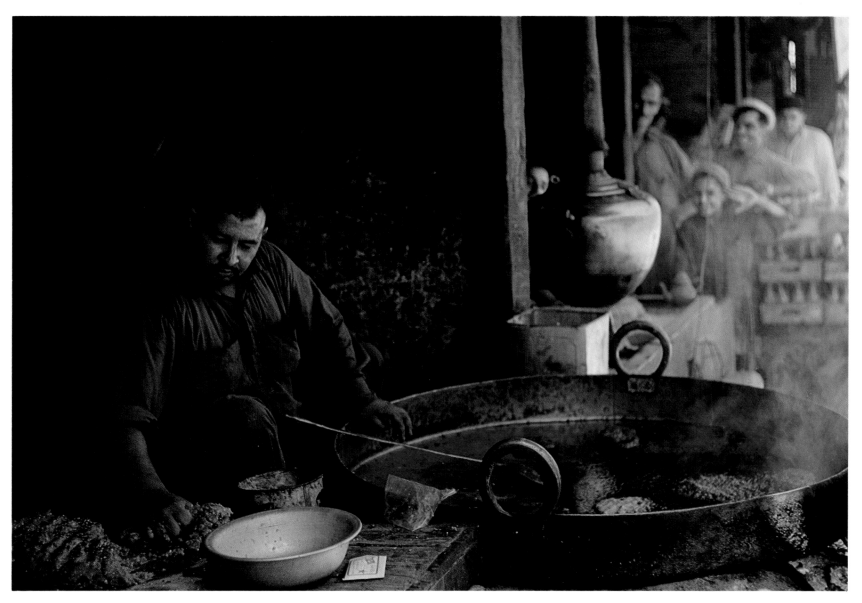

Landi Kotal at Khyber Pass, Pakistan

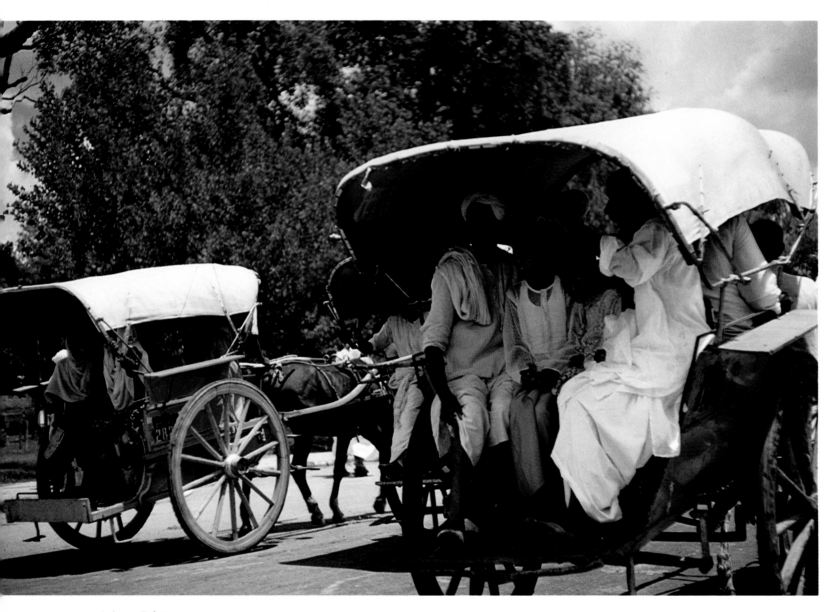

Lahore, Pakistan

The
Sound
of
Silence

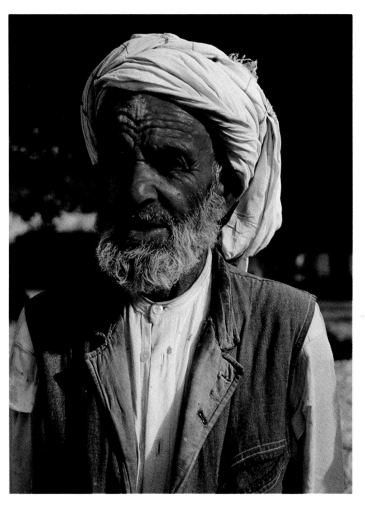

Kabul, Afghanistan

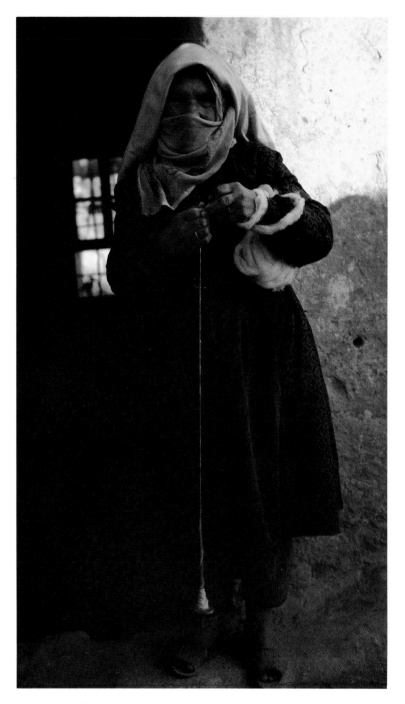

Goreme, Turkey

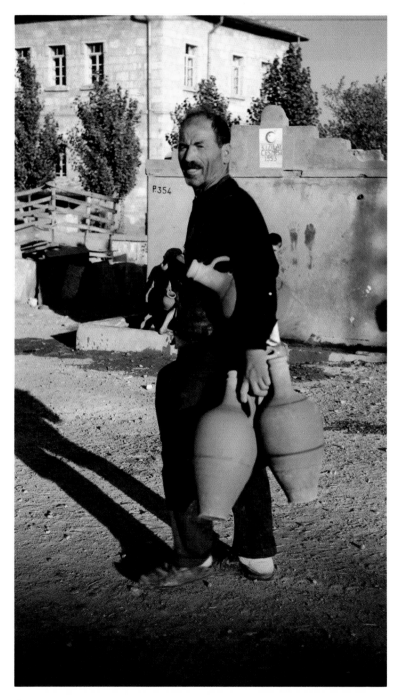

Goreme, Turkey

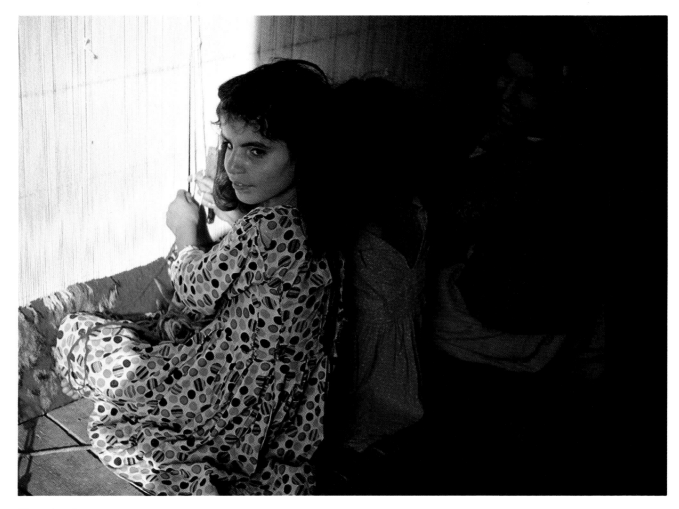

Hamadan, Iran

Behold!

Let no evil come.

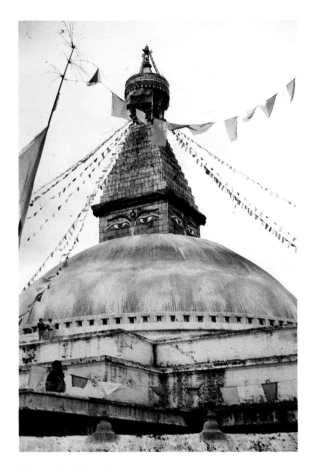

Katmandu, Nepal

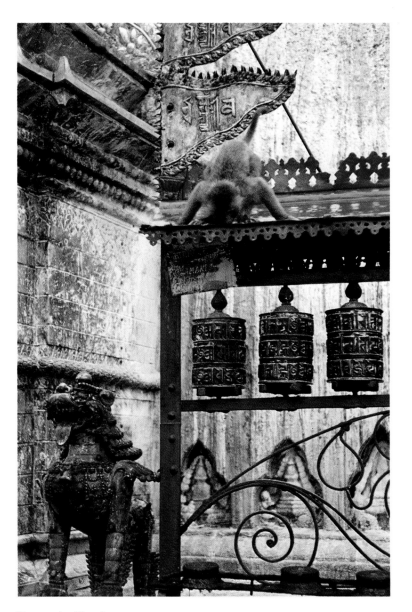

Katmandu, Nepal

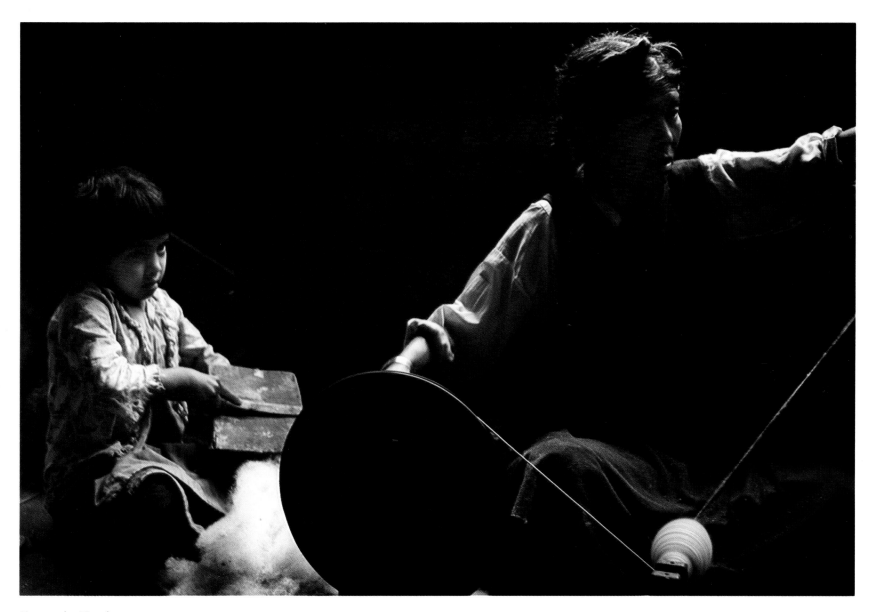

Katmandu, Nepal

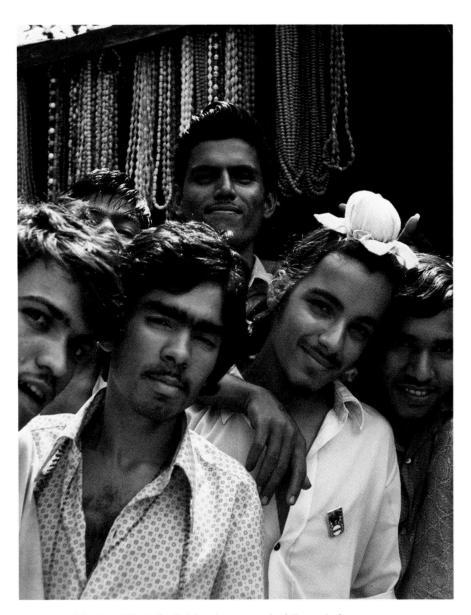

My friend Papindar Pal Singh, Aurangabad Caves, India

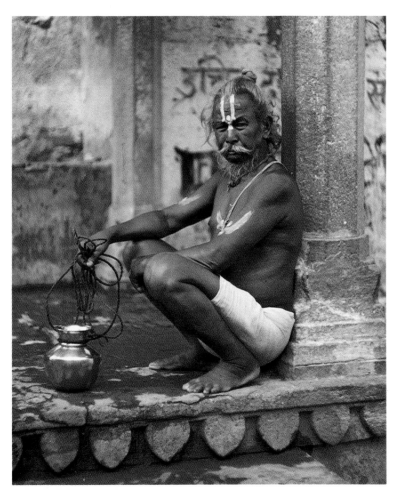

Jaipur, India

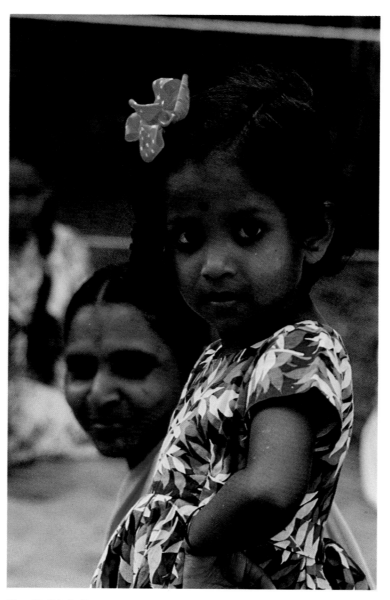

New Delhi, India

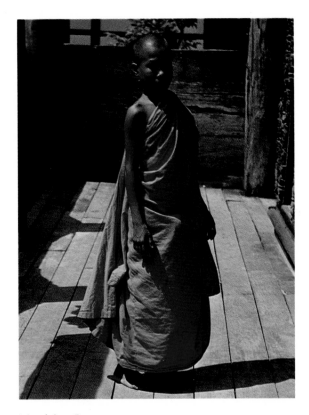

Mandalay, Burma

The Truth:
I declare to you that
within the body you can
find the world, and the
origin of the world, and
the end of the world, and
the path—to all goals.

BUDDHA

Bangkok, Thailand

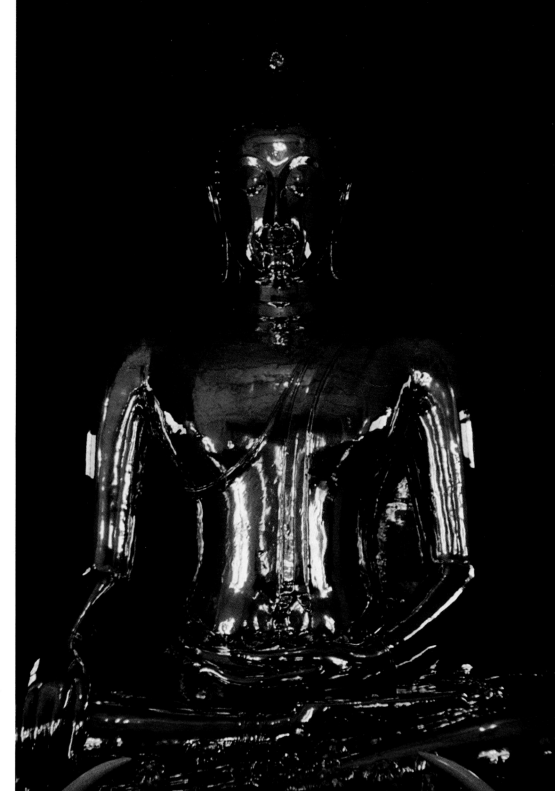

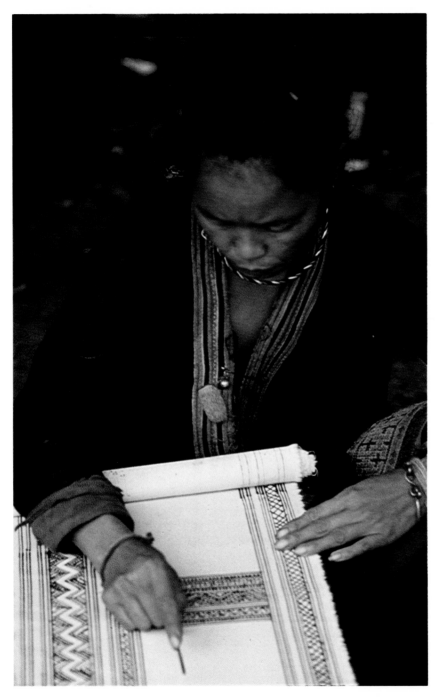

Chiang Mai, Thailand

The
Fundamental

The
Elemental

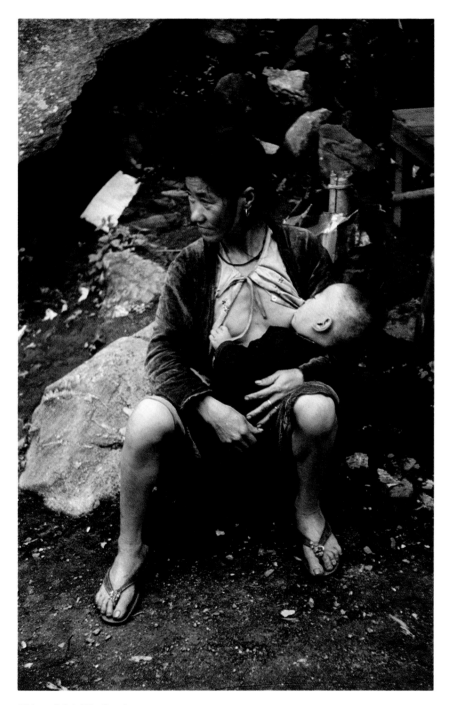

Chiang Mai, Thailand

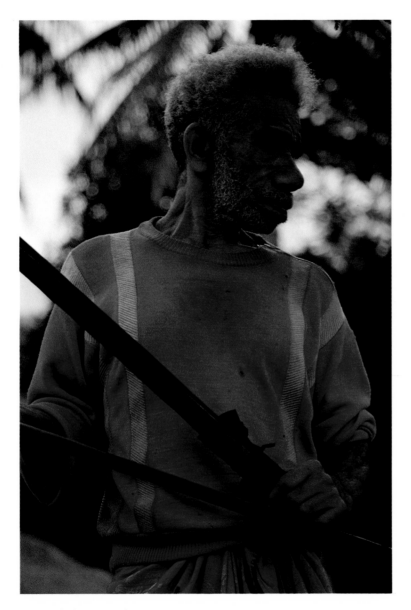

The
Chief

New Caledonia

The
Subordinate

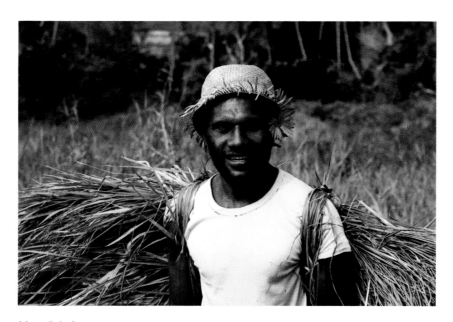

New Caledonia

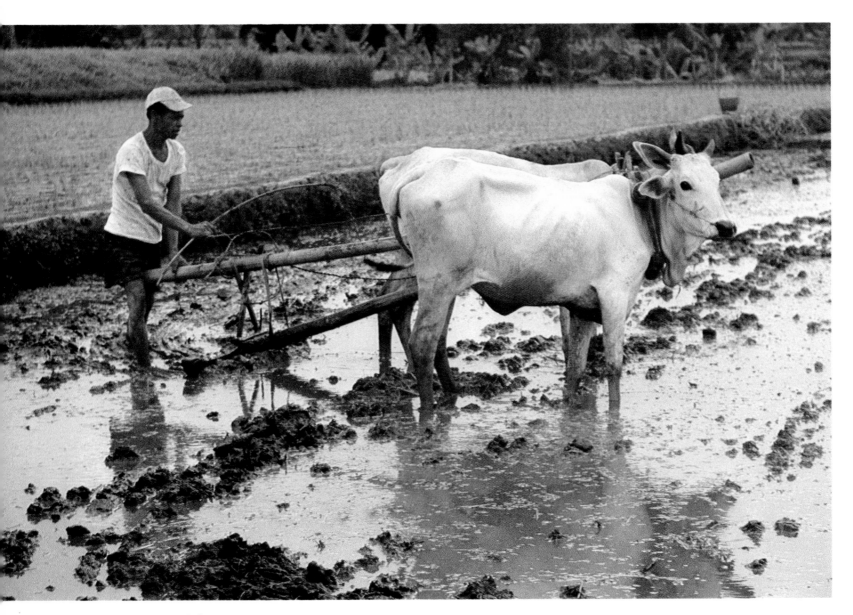

Jogjakarta, Java, Indonesia

The
Laborers

Jogjakarta, Java, Indonesia (Batik)

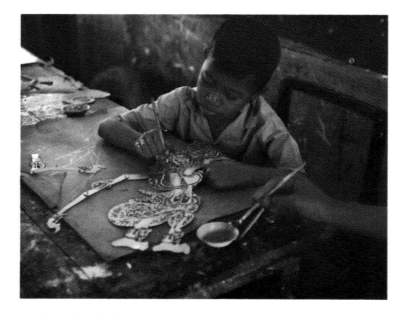

Jogjakarta, Java, Indonesia

Music is the Pulse
of the Universe

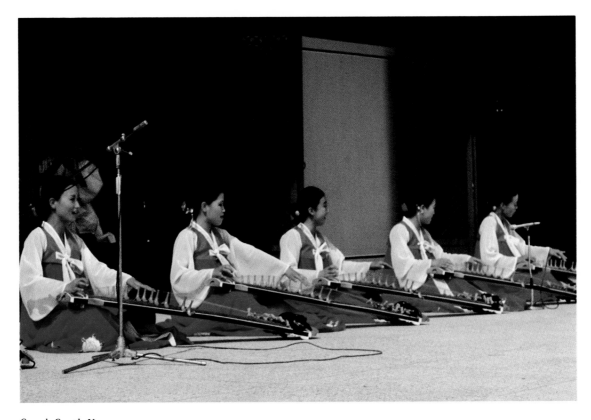

Seoul, South Korea

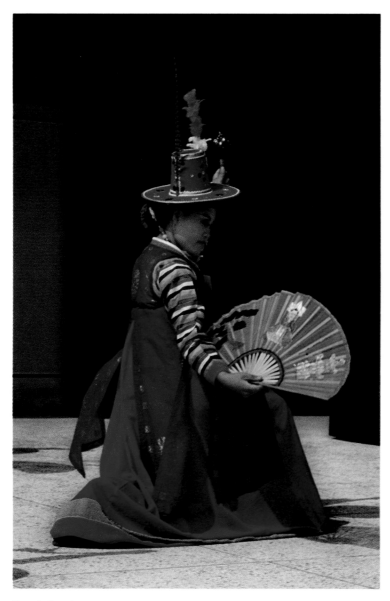

Seoul, South Korea

Tana Island, New Hebrides

Nature,
Thy Name
is
Woman

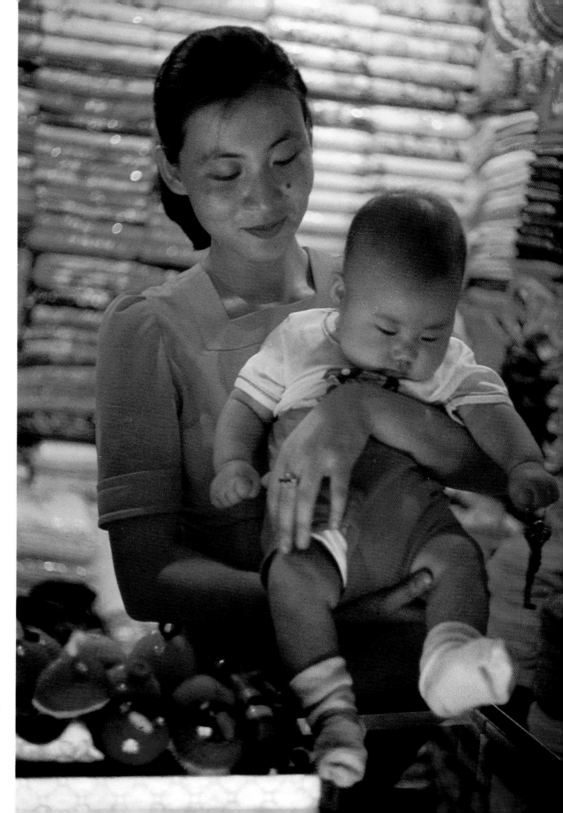

Seoul, South Korea

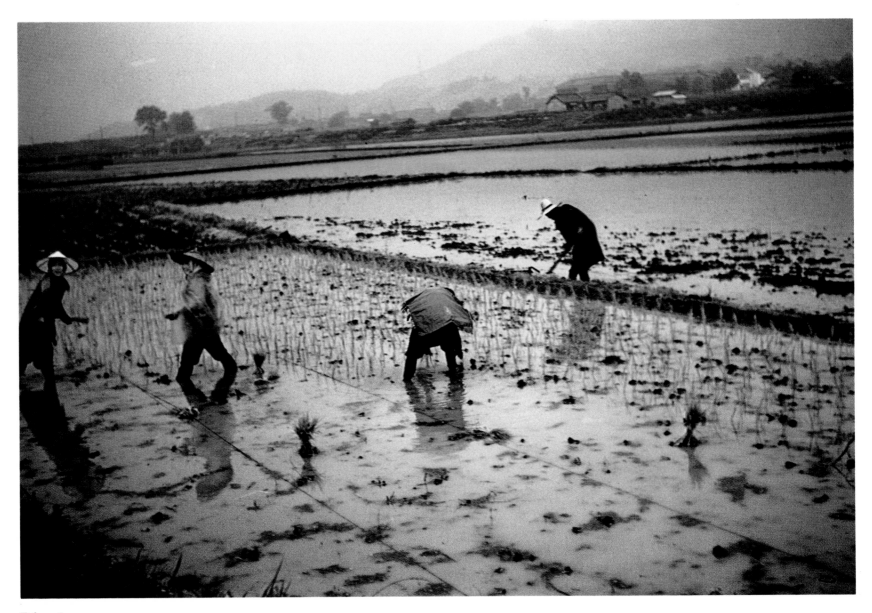

Tokyo, Japan

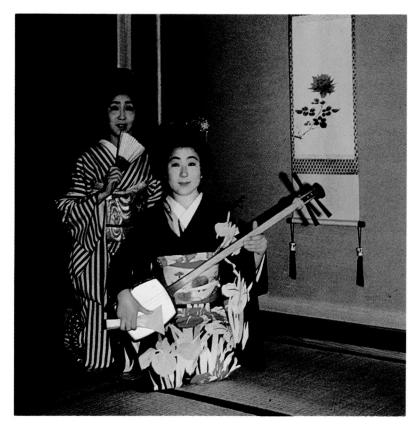

Tokyo, Japan

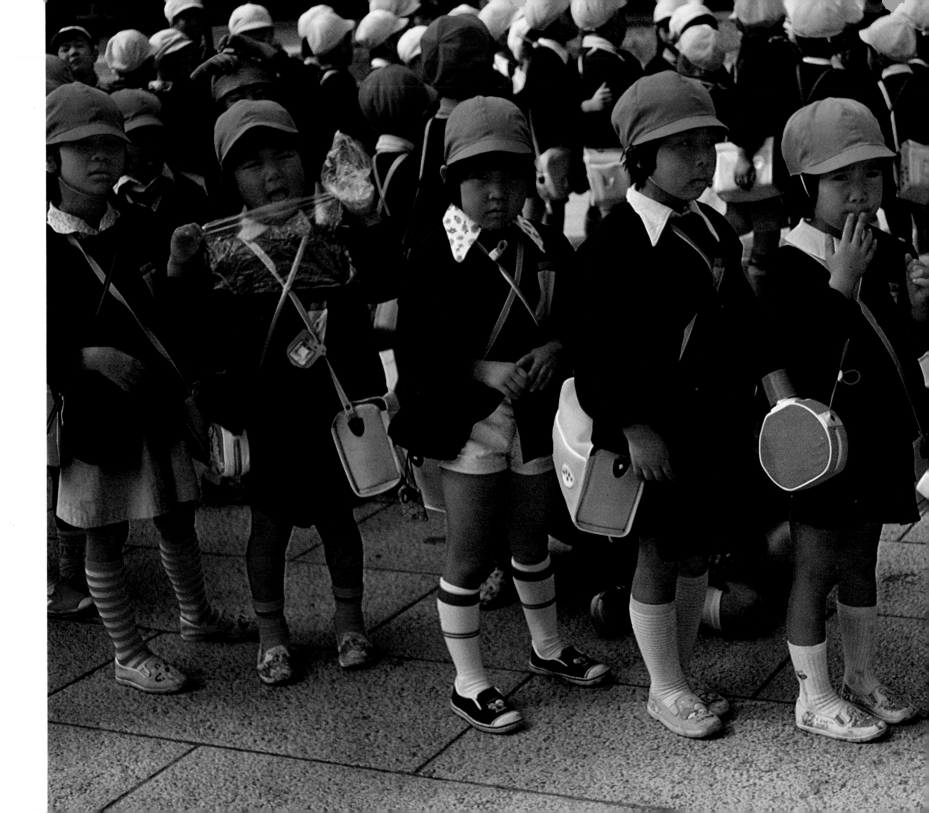

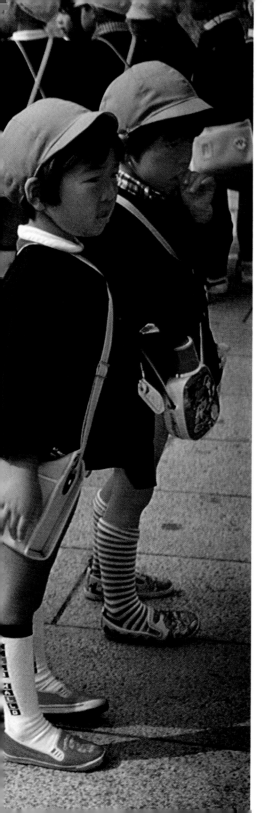

Tokyo, Japan

The Joy of the Child

The Great Wall of China—
A Wonder of the World

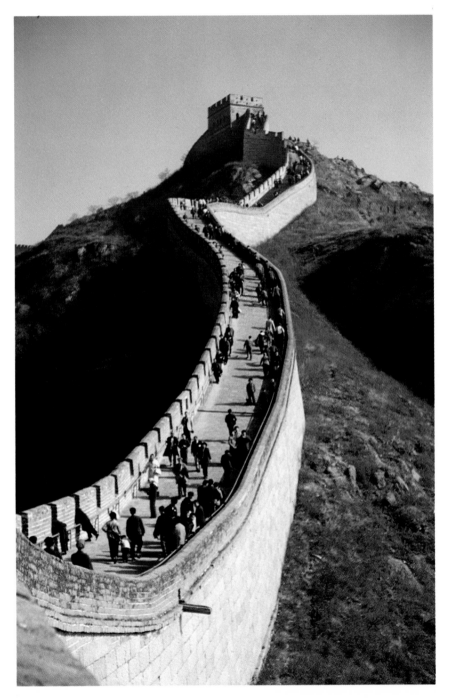

Peking, China

Body

and

Mind

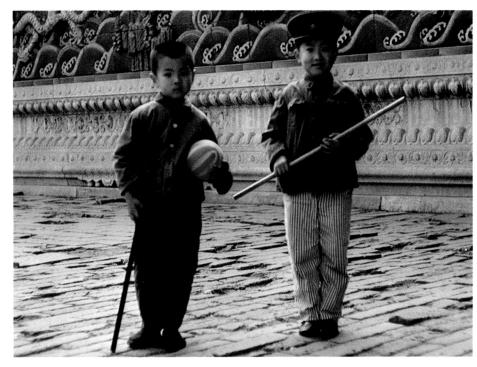

Peking, China

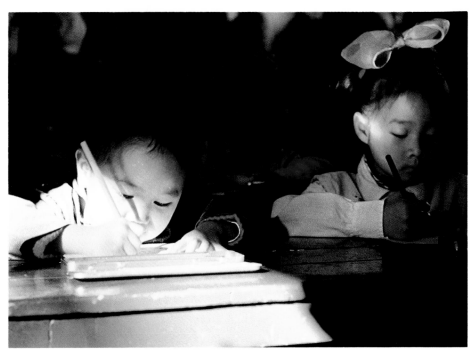

Kweilin, China

The Task

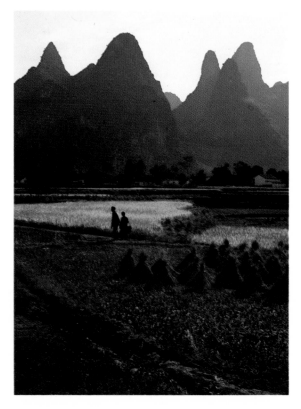

Kweilin, China

Kweilin, China

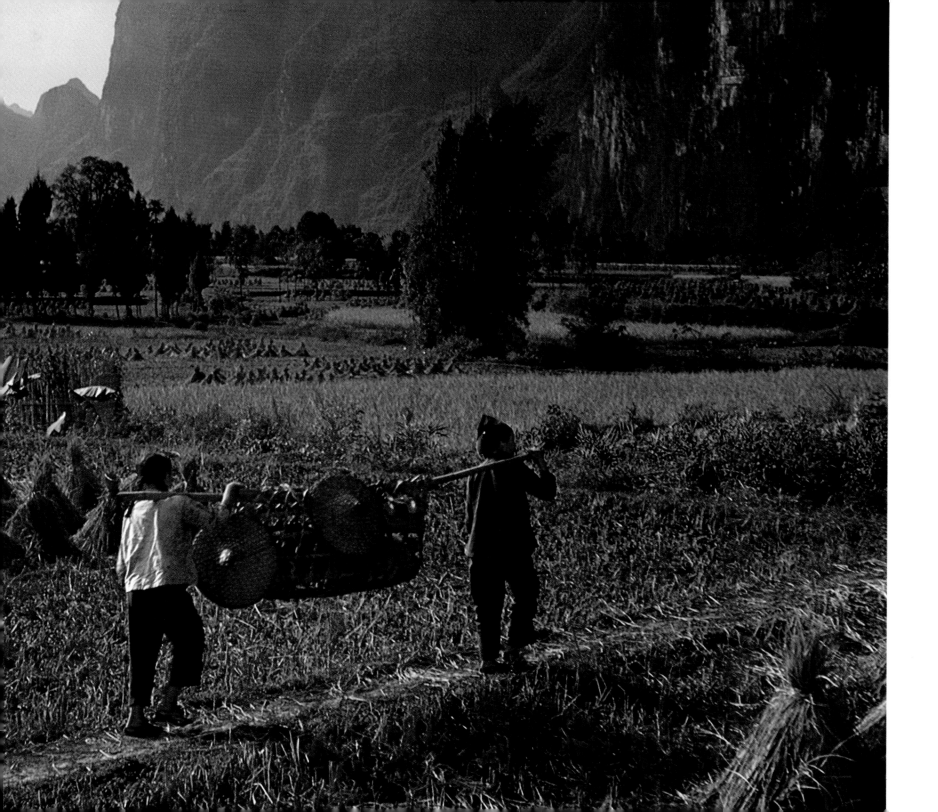

The Skill

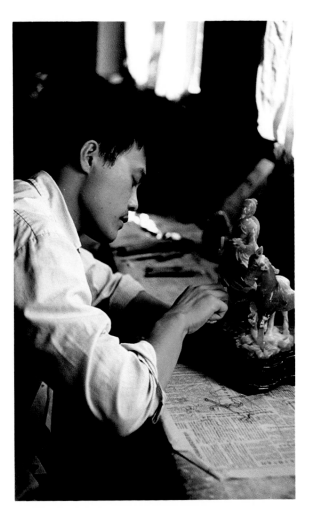

Kweilin, China

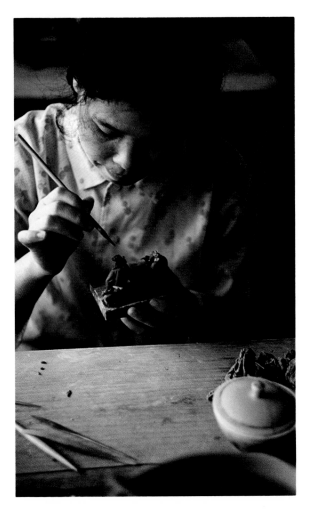

Foshan City, China

The Tranquil Place

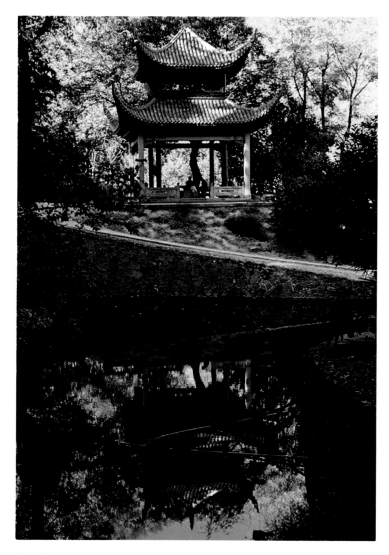

Kweilin, China

A Way of Life

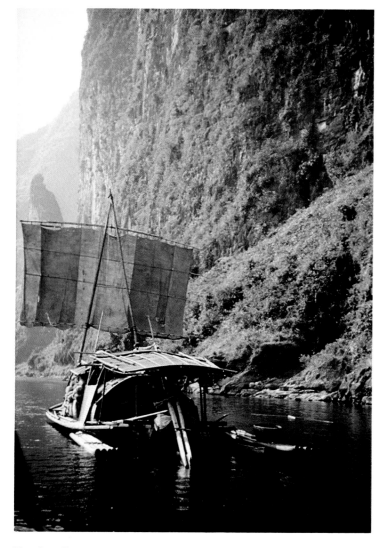

Kweilin, China

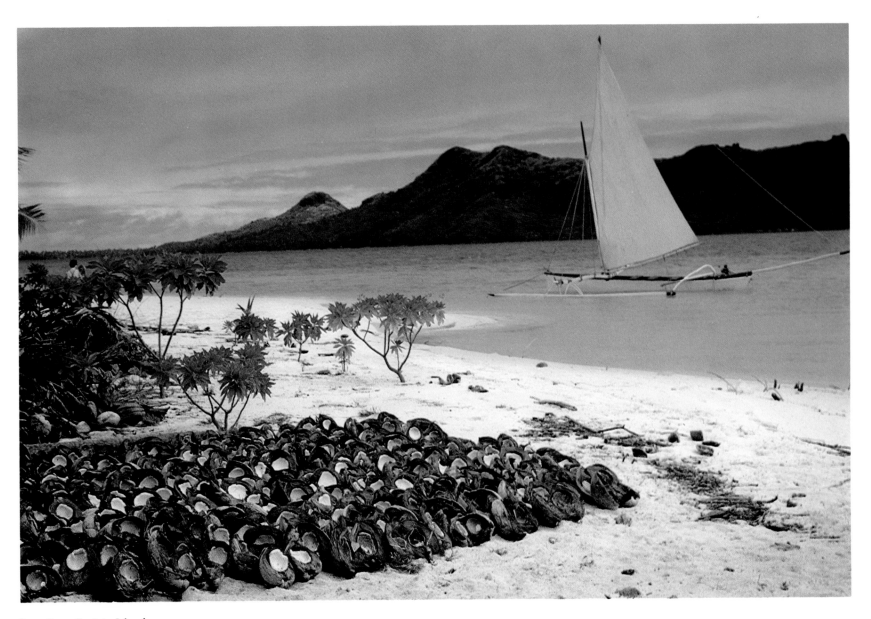

Bora Bora, Society Islands

Life from the Sea

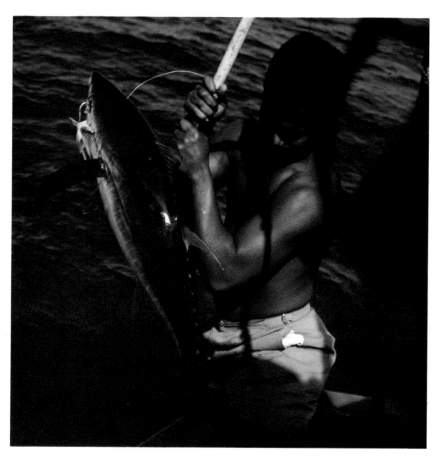

Fiji Island

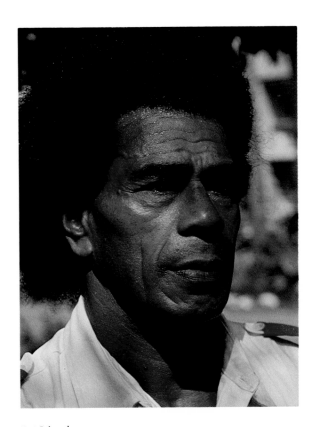

Fiji Island

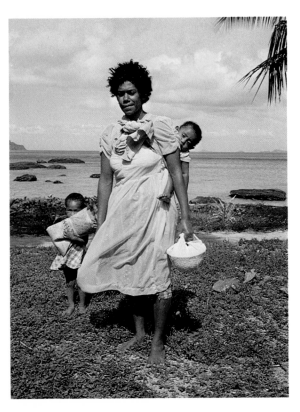

Fiji Island

The Cook

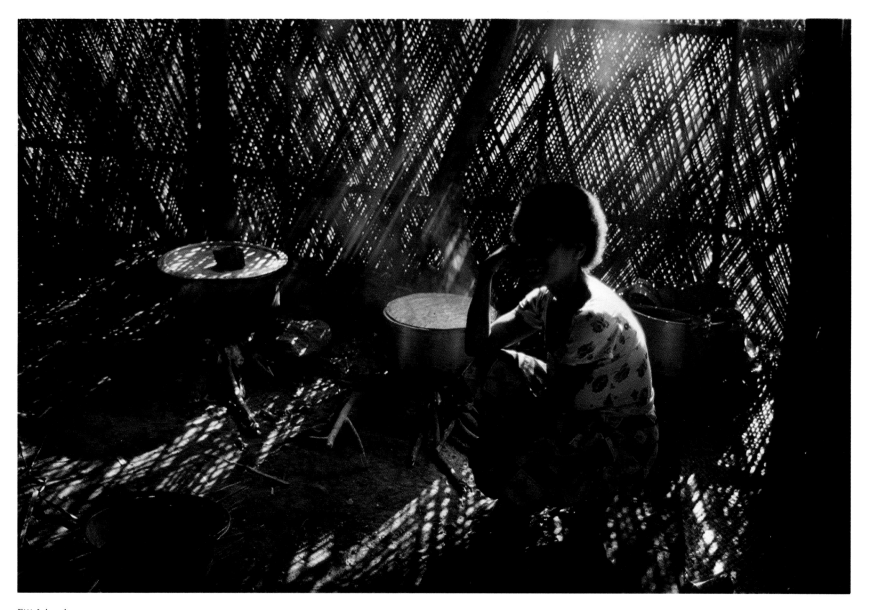

Fiji Island

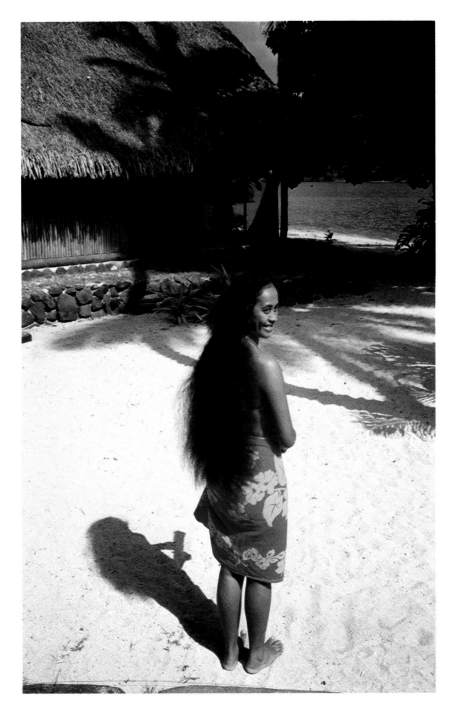

New Caledonia

Moorea, Society Islands

The
Laughing
Hour

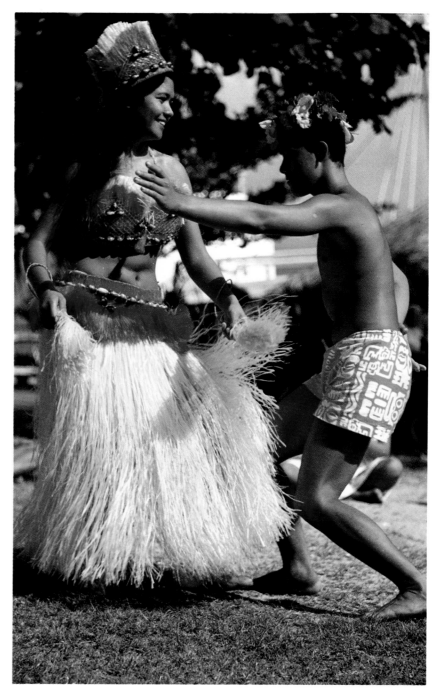

Moorea, Society Islands

Art—Yes

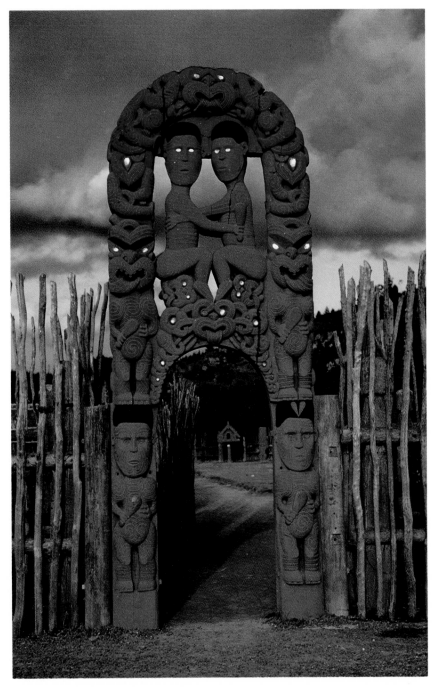

Maori carving, Rotorua, New Zealand

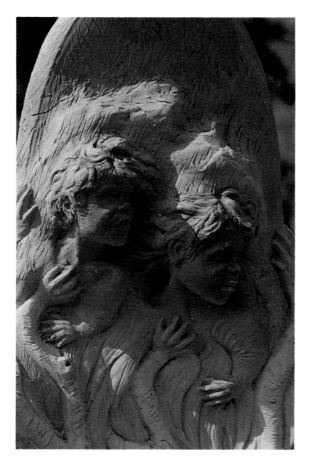

Aboriginal sculptures, Alice Springs, Australia

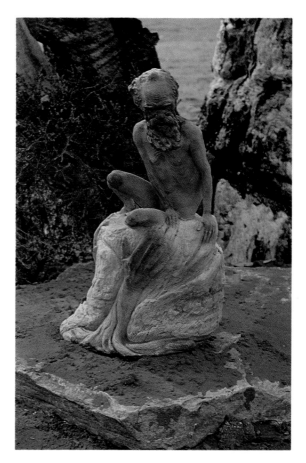

Aboriginal sculptures, Alice Springs, Australia

Behold
thy
Beauty

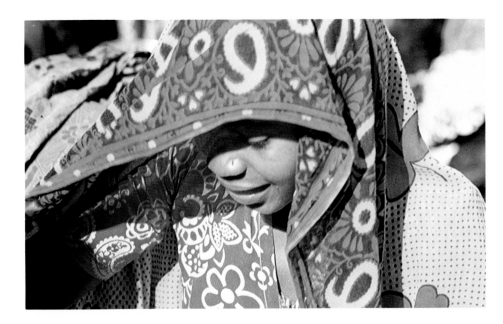

Anjouan Island, Comoros

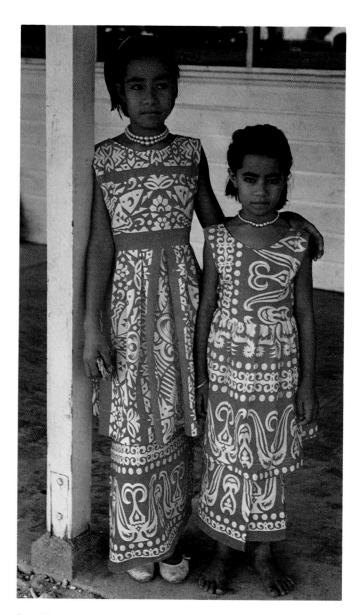

Pago Pago, American Samoa

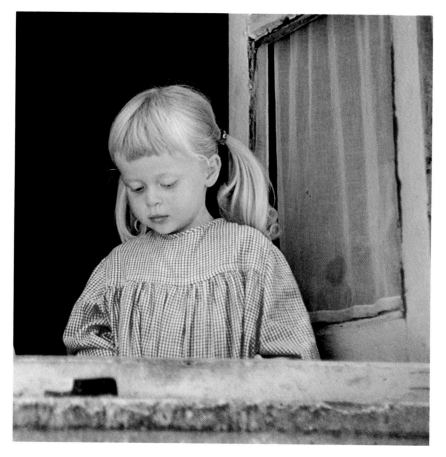

Dubrovnik, Yugoslavia

Time

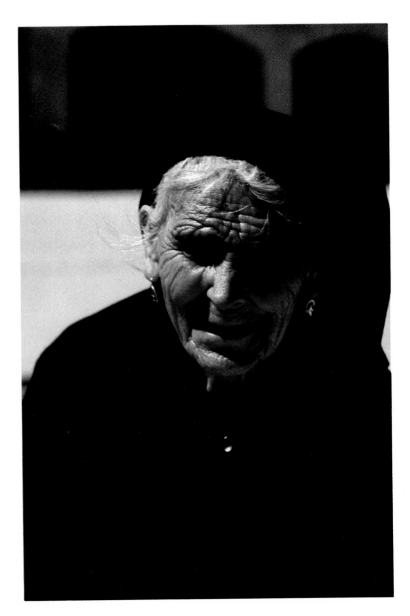

Fatima, Portugal

The Timeless

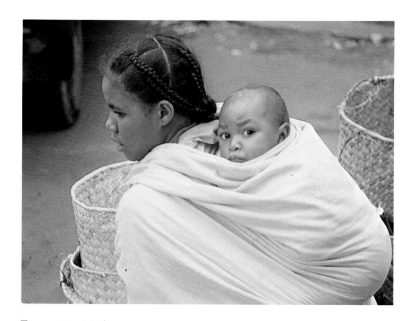

Tananarive, Madagascar

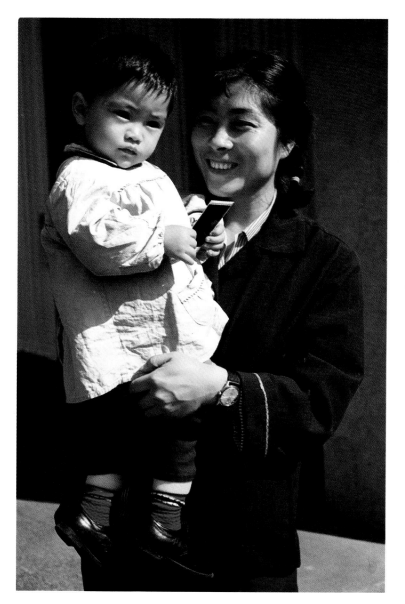

Changsha, China

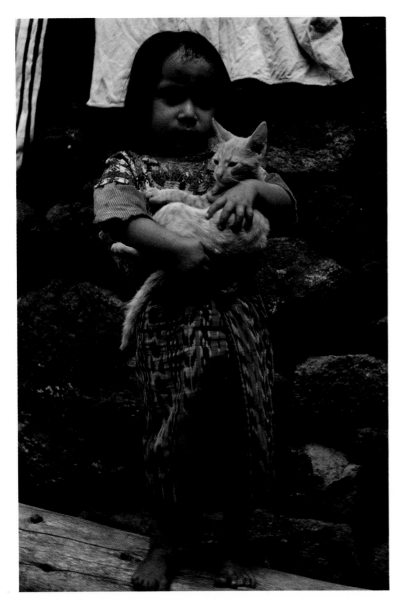

Santiago, Guatemala

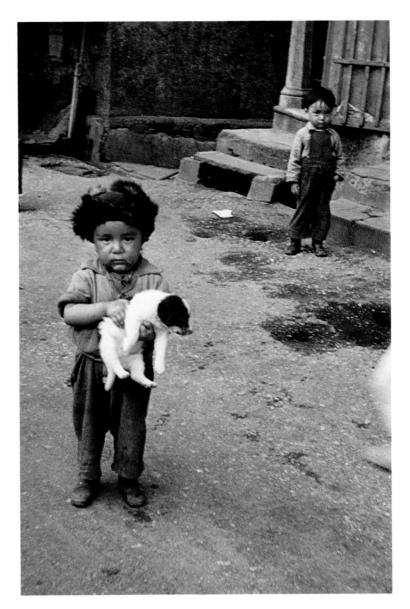

Darjeeling, India

The Wonder
that is
the Child

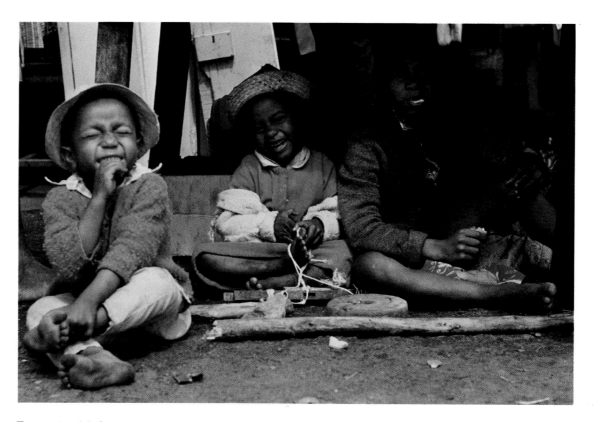

Tananarive, Madagascar

The Lilt of Life

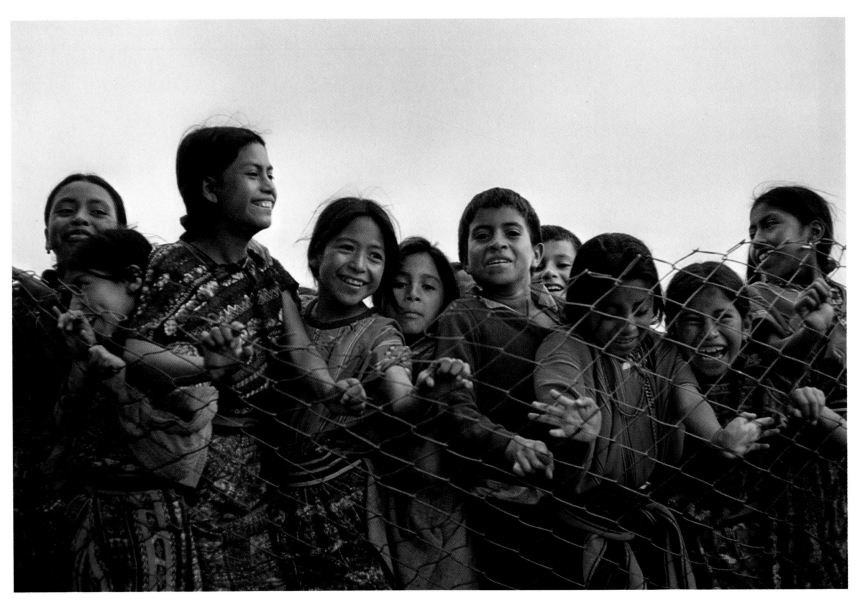

Lake Atitlan, Guatemala

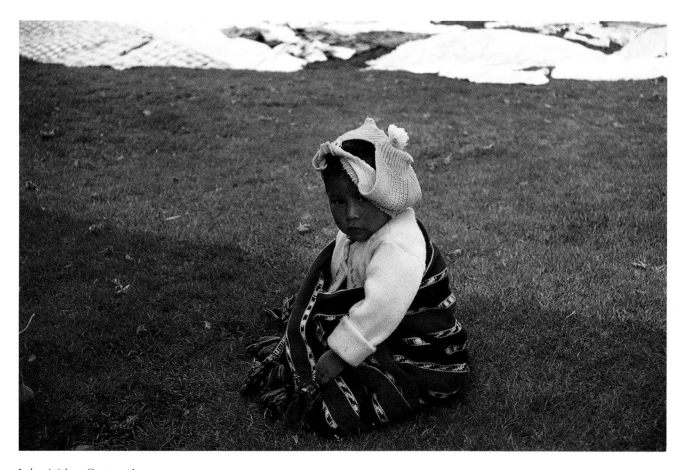

Lake Atitlan, Guatemala

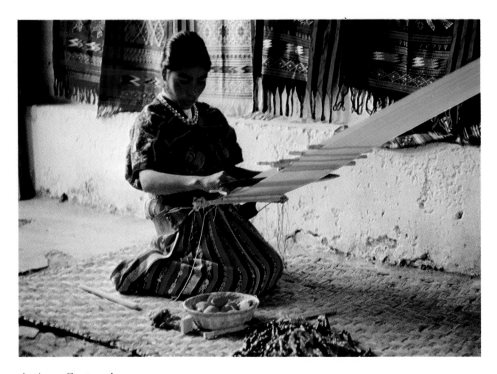

Antigua, Guatemala

Antigua, Guatemala

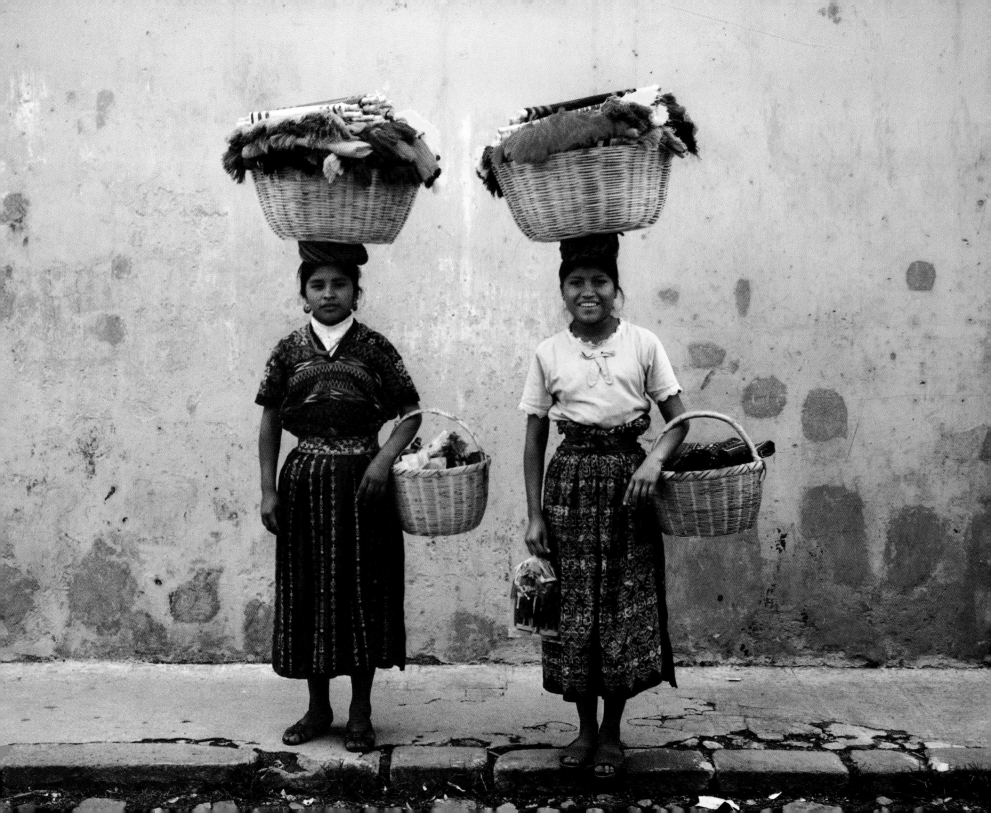

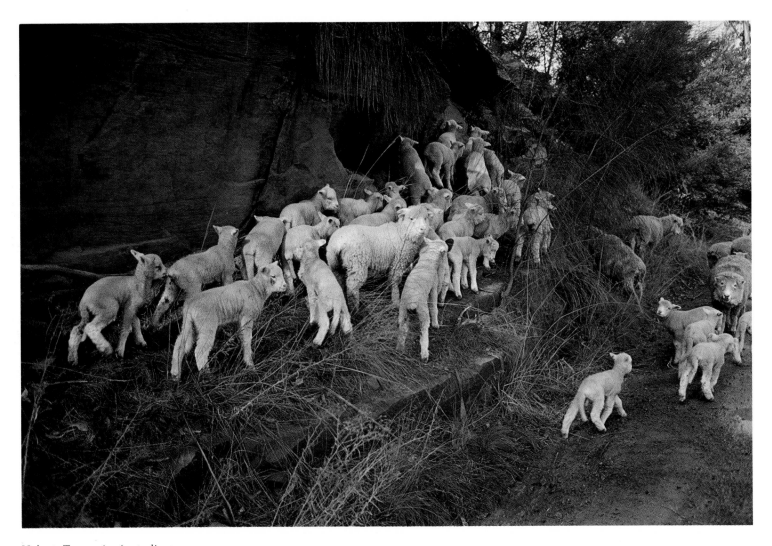

Hobart, Tasmania, Australia

The Lord is my shepherd;
I shall not want.

PSALMS 23

Norfolk, Tasmania, Australia

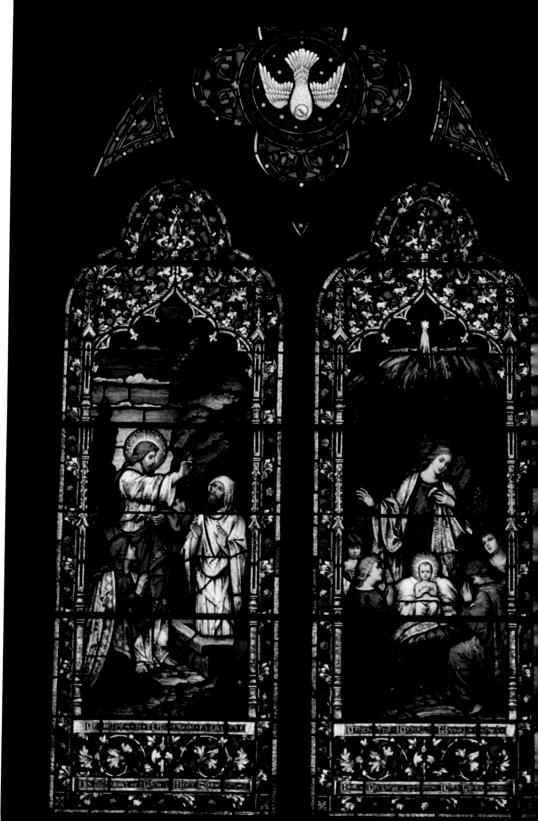

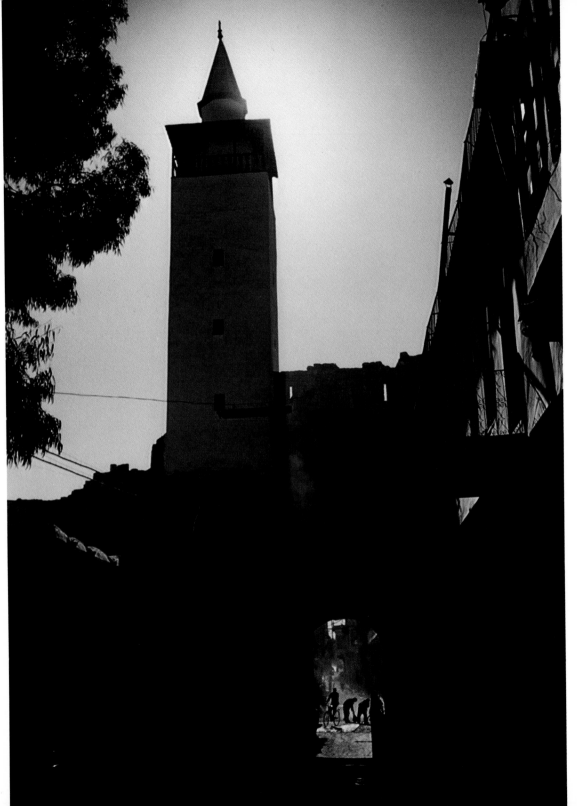

Damascus, Syria

The Street called Straight.

ACTS 9

Toledo, Spain

The Icon

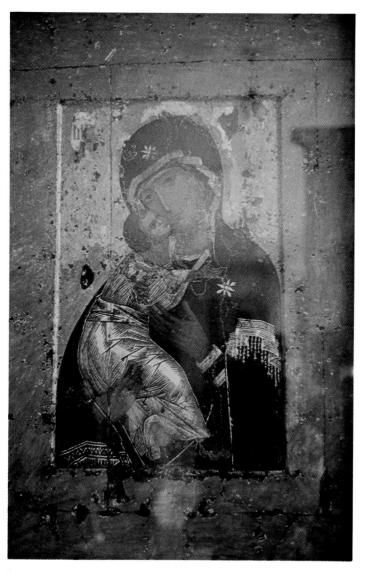

Moscow, Russia

Innsbruck, Austria

Bacau, Romania

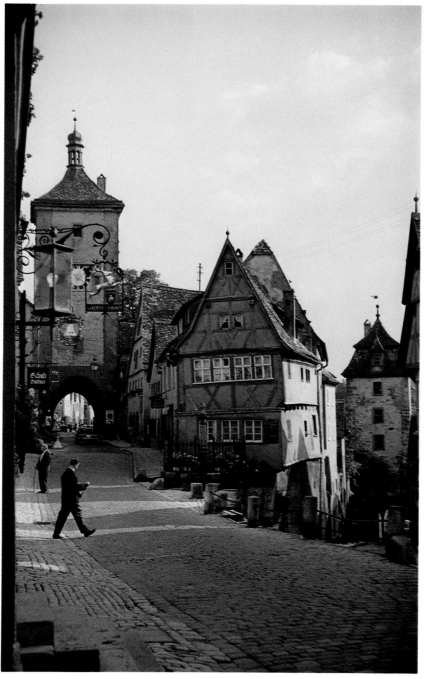

Rothenburg, Germany

The
Rothenberger
Origin

The Smile of Life

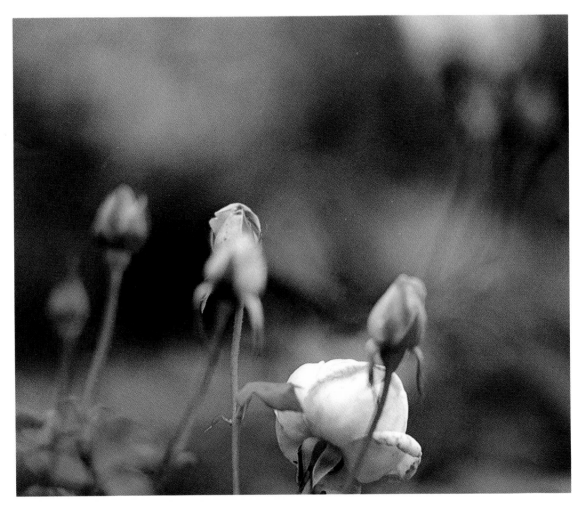

Romeo, Michigan

Ageless Beauty

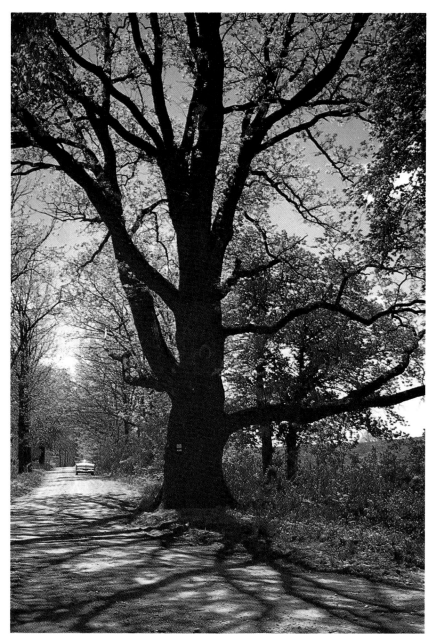

Romeo, Michigan

Homeward Bound!

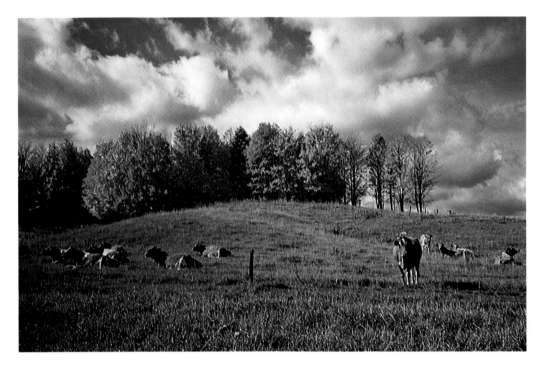

Boyne City, Michigan

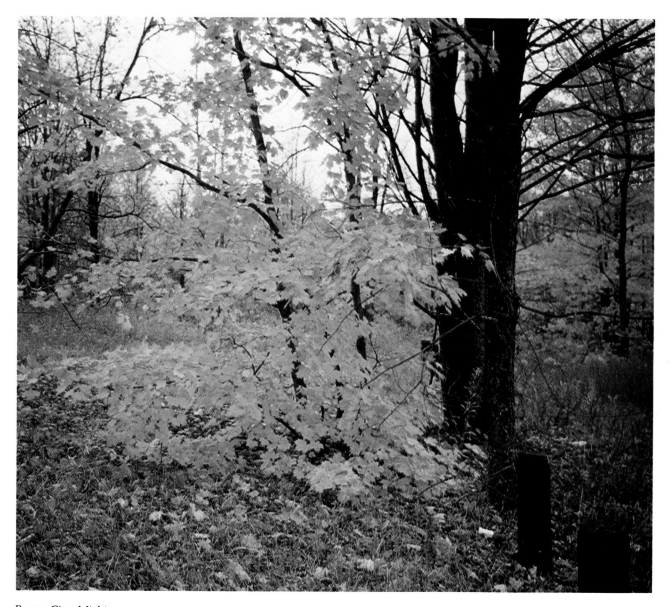

Boyne City, Michigan

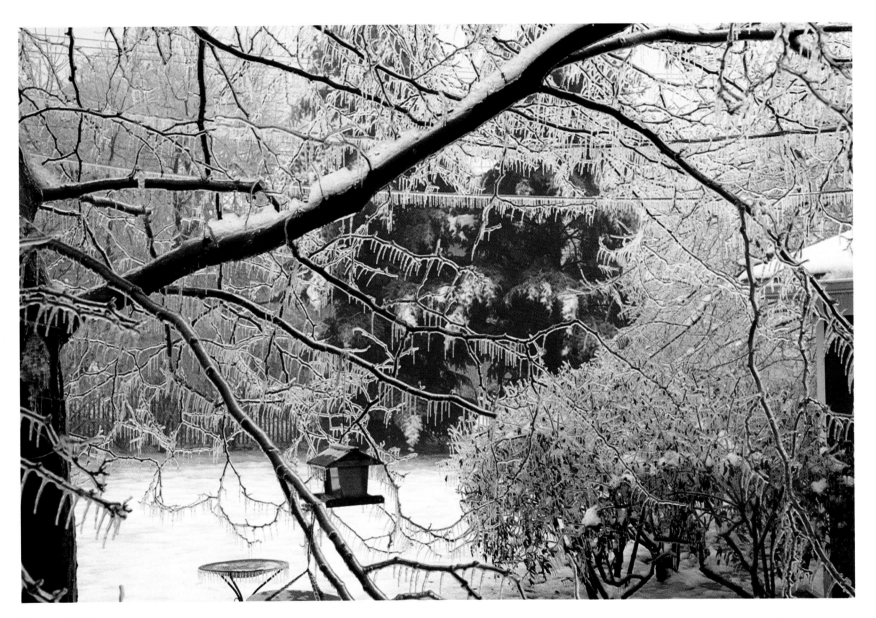

Romeo, Michigan

Home!

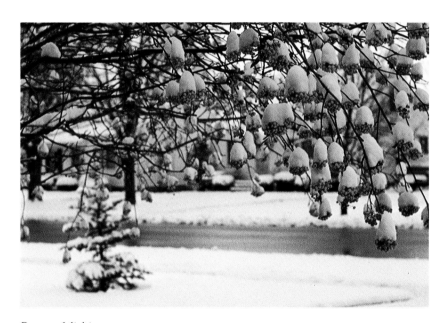

Romeo, Michigan

Davy

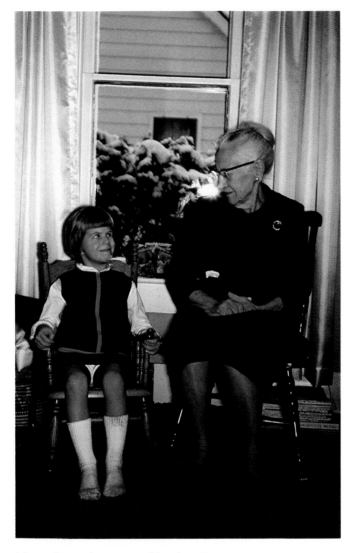

My mother and great-granddaughter Danya

My Mother
Had the privilege of choice been granted to me, I would not have chosen more wisely than she who was my own.

Romeo, Michigan

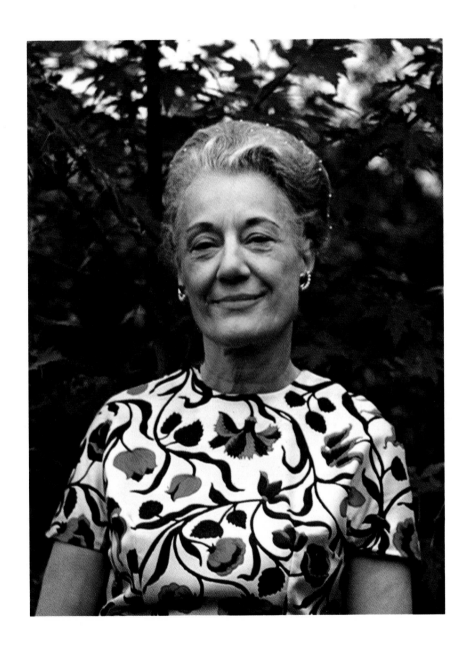

Epilogue

It is home again to the dearly familiar, and it is good that it be so.

From the sunrise of my world journey to its sunset, the grace of your presence has gladdened me, and I thank you for it, for indeed the sharing has made more manifold my joy.

Sylvia Rothenberger Miller